Published by **Hero Collector Books**, a division of Eaglemoss Ltd. 2021
Eaglemoss Ltd., Premier Place, 2 & A Half Devonshire Square, EC2M 4UJ, LONDON, UK
Eaglemoss France,144 Avenue Charles de Gaulle, 92200 NEUILLY-SUR-SEINE

General Editor: **Ben Robinson**
Project Manager: **Jo Bourne**
Designer: **Stephen Scanlan**

With thanks to the team at CBS: John Van Citters, Marian Cordry
and Risa Kessler

The contents of this book were originally published as part of
STAR TREK – The Official Starships Collection by Eaglemoss Ltd. 2013-2021

To order back issues: Order online at
www.shop.eaglemoss.com

ISBN 978-1-85875-989-0

Printed in China

10 9 8 7 6 5 4 3 2 1

www.herocollector.com

DESIGNING STARSHIPS
DEEP SPACE 9 AND BEYOND

CONTENTS

ACKNOWLEDGMENTS

DEEP SPACE NINE was a massive departure for *STAR TREK*. Instead of being set on a Federation starship the series took place on an alien space station with a completely different design aesthetic. Even the threats that the crew faced involved new species who posed new design challenges. Everything had to be thought through and created from scratch. A talented team of artists set about the task under the guidance of Production Designer Herman Zimmerman.

The same team tackled the *STAR TREK: THE NEXT GENERATION* movies, which often called for alien ships with an epic scope, and took *STAR TREK* back to its beginning in *ENTERPRISE,* which involved creating 'primitive' ships for species we knew well. Throughout this, they built on the work done by Matt Jefferies and Andrew Probert, who worked on the original TV series and first *STAR TREK* movie respectively.

We'd like to thank, in no particular order, concept artists John Eaves (whose work dominates this volume), Jim Martin, Rick Sternbach, Andrew Probert, Doug Drexler, and ILM's Mark Moore, who collectively designed the ships on the pages that follow. All of them were incredibly generous with their time and we cannot thank them enough.

This volume also features the work of the late, great Matt Jefferies, who as well as designing the original *Starship Enterprise,* created the Klingon ship that would menace it, giving the Klingons a look that survives to this day.

Our special thanks to the team at CBS Consumer Products: Risa Kessler, John Van Citters, and Marian Cordry.

DESIGNING
DEEP SPACE 9

The new *STAR TREK* series called for an alien space station
that could be as instantly recognizable as the *Enterprise*…

▲ Rick Berman wanted the design for Deep Space 9 to be instantly recognizable, clearly alien and unlike anything that had come before.

From the moment work began on STAR TREK: DEEP SPACE NINE in 1992, the goal was to create something different. This was never going to be just another starship- based show, it was to be set on an alien space station at the edge of Federation space. Co-creators Rick Berman and Michael Piller wanted it to feature a different kind of storytelling and, as they told production designer Herman Zimmerman, they wanted it to have a very different look.

Fortunately, Zimmerman remembers, he was given the time to come up with new approaches: work began three months before the cameras turned over. "Most shows give you a couple of weeks or maybe a month," he says. "This was an enormous gift in terms of creative noodling. We

had a chance to try things that didn't work and try things that eventually did work."

Zimmerman had left STAR TREK: THE NEXT GENERATION four years earlier at the end of season one. He was delighted to be back at Paramount and to be given a blank slate for the new show. He set up a new art department to work alongside the TNG team, but several key members of his staff worked on both shows, in particular concept artist Rick Sternbach and graphic designer Mike Okuda. "Mike, Rick and I were among the first hired," he recalls. "Mike and Rick had a lot to do with the look of the exterior of DS9, and we had a wonderful sketch artist, Ricardo Delgado."

While Sternbach and Okuda were working on the exterior of the station, Zimmerman's new art

TREK
STARBASE SHAPES ②

TREK
STARBASE SHAPES ②

department started work on the sets that would be found within. "We had a couple of really good set designers who added a great deal to the look of the show: Nathan Crowley and Joe Hodges, both of them English."

Hodges had worked on *TNG*'s third season under Richard James before departing. In the interim he'd worked on two massive films: 'Hook' and 'Dracula,' where he'd met Crowley, who he brought with him to *STAR TREK*. As Hodges remembers, they were both young and massively ambitious. "We terrorized Herman," he laughs. "We had just come off 'Dracula,' this huge movie and it seemed as if we were beating him up every day about things we wanted to do. We were totally into building things and making molds of them, knowing that we'd be able to repeat them. That's how we achieved all those big windows.

▲▼ Rick Sternbach began work by pulling out the familiar designs for space stations (above). Meanwhile, Ricardo Delgado considered more radical approaches (below).

OKUDA
DS 9 3/26/

"Herman used to say, 'This is a TV show. There's no way we can afford it.' I said, 'I know it's going to take two weeks to build that mold, but once we have it, we can vacuform it, and we can cut it in half and it will be the doorways, or the light fittings, anything we want for seven years.' Herman would shake his head but then he'd come back half an hour later and say, 'You know what, we'll do it.' I apologized years later, but he said, 'If it wasn't for you, we would never have been nominated for all those Emmys.'"

Meanwhile, as Hodges explains, Sternbach and Okuda were working on the outside of the Cardsassian station. "TNG was still going. Rick and Mike were in the old art department and we were in a different building."

Rick Sternbach remembers that when they started work, the brief for the station was very different: "At the time the overall concept had not really been nailed. They offered us some very basic ideas about what the station was all about and we were to come up with some early concepts."

As usual, Sternbach began the design process by sketching out some possible shapes for the station. He started with some familiar approaches that took the proportions of existing Federation stations and pulled them about.

Zimmerman picks up the story: "The producers weren't sure exactly how they wanted to direct us with the visual elements. We started out charged with getting a 'Tower of Babel' concept of a space station that was built over a couple of thousand years of separate, disparate cultures, so the technology from one part of the station to another would be of various ages and various cultures, not necessarily interfacing one with the other."

Eng. Scale 60

Shuttered Windows
Close in an emergency?

command center (semi-armored)

command protected
by upper deflector masts

Approx 560' ⌀

shaft (personnel)

access to various cargo
bays, fuel depots,
etc

cargo
elevator
(internal)

Deflector Coil Access

MANUV.
THRUSTER (6)

external
power
conduits
(3-6)

Reactor
Control

Deflector
Control
power bus, etc.

Exhaust Cone
Glows

This led Sternbach and Okuda to experiment with irregular shapes, where modules had been added over time. "The initial take," Sternbach says, "was that it was a very old, ancient type of a station, maybe not symmetrical in shape. Perhaps it was built in a sort of hodge podge nature."

"It was a mish mash of different cultures," Okuda adds." It was supposed to be really thrown together. I did a whole bunch of really weird, different things."

Although much of the work was still sketched with a pencil, by this point Sternbach and Okuda had access to basic 3D modeling software, which they used to build structures they could examine from different angles. As Sternbach explains, the technology allowed them to produce a lot of designs very quickly. "We started with a very large number of sketches and very quick CGI shapes

that we could build in our computers. We had some 3D modeling software on the Mac. We could create a lot of shapes, make multiple copies of them and put little pieces together and rotate them around and see how they would look. Also, to see if they would provide enough of a strange alien look to be approved."

At this point, Mike Okuda recalls, they hit on a design concept that seemed to have promise. "The one that went the furthest was a version that had started out inspired by an airport terminal," he explains. "Then it became much more complicated and started looking like an oil derrick. Herman, Rick and I liked it a lot and Berman and Piller liked it, so Rick went to the point of actually building a very detailed study model. We walked into a meeting with Berman and Piller and said this is cool."

▲ Sternbach and Mike Okuda used basic 3D software and traditional pen and ink drawings to work up a series of potential designs for the station, which they had been told had been built up by different races over hundreds of years.

▲ This design for *DS9*, which Okuda describes as being based on an airport terminal and looking like an oil derrick, nearly made it through, but when the producers looked at the study model (above, right) they decided it wasn't what they wanted.

For a while everyone was keen on the model, but as Berman and Piller considered it further, they started to have doubts; somehow the design wasn't what they had in mind.

"In the last analysis," Zimmerman says, "it wasn't slick enough or alien enough to satisfy Rick Berman's desire for a show that would not compete with *TNG* and would not be derivative of any existing features or of the original series."

By now the art department had presented countless sketches as they explored different approaches. As Zimmerman remembers, Berman decided that the problem was actually to do with the concept of the station itself. "Rick said, 'OK, forget about the Tower of Babel, forget about the various cultures; give me the most alien thing that you can create that could be a space station at the edge of the Galaxy.' One of the things he said was, 'No matter where you are, if you can see your television set, from the corner of the kitchen, from a chair in the living room, looking up from your

homework in bed, when you see that image on the screen I want you to know immediately that it is Deep Space 9 and nothing else.' That actually was a pretty tall order, to design something that is immediately recognizable for what it is and couldn't be anything else."

Given the new brief, the art team looked back over all the initial ideas they had explored. Amongst them was a sketch Zimmerman had produced that was built around two rings that were at right angles to one another.

"One of the earliest pictures was something that Herman had done," Okuda says. "He'd liked it a lot but initially it wasn't the direction that Berman and Piller wanted to go in. So when the oil derrick was rejected, Herman said, 'You know, I really like the rings.' He asked Rick Sternbach to play with it and between the two of them came up with variations of it."

Zimmerman explains that the idea for the design was based on a practical consideration. "What I

▶ This Ricardo Delgado drawing is based on a concept that Herman Zimmerman had suggested earlier in the process. This design involved a series of rings at angles to one another.

▼ Sternbach took Zimmerman's idea and started to develop it, turning the rings into hoops and experimenting with their relationship to one another.

(Mounting Rod fits behind plate details)

"small" ENT.

INSIDE **DEEP SPACE 9**

A lot of the exterior details on Deep Space 9 were based on the work that set designers Joe Hodges and Nathan Crowley did for the station interiors, in particular Ops and the Promenade. Herman Zimmerman tasked them with coming up with a new, obviously alien style of architecture. The work they did was illustrated by Ricardo Delgado, both to show it to the producers and to document it for prosperity.

"My main job was Ops," Hodges remembers. "There were two pits on the stage we were using. I wanted to make the

elevators work because I'd never seen that on *STAR TREK*. I wanted to see these things come out of the ground. I always had a problem with the *Enterprise*'s massive screen. To me it doesn't matter who you are – even Picard – if you're talking to a ten-foot head you've got to feel intimidated. I didn't want ramps; I wanted steps."

The design for the entire station was based on a series of shapes that could be made using a mold of a circular section. Hodges and Crowley worked out that they

could create a variety of shapes, including the eye that forms the viewscreens, by using sections of the mold and combining them in different ways. Even small parts of the mold could be used to create details.

Seen up close, the molded pieces had a series of subtle indentations and raised sections that gave them an interesting texture. This same approach was applied to the outside of the station, which Zimmerman felt made it look simple from a distance, but more complex as you got nearer to it.

started with was asking, 'What holds a space station in space?' It has got to have some kind of artificial gravity. What creates artificial gravity? We have artificial gravity on ships today; they have gyroscopes that keep them upright. So I thought a gyroscope shape was a basic form that we could work with. We also vaguely connected the gyroscope shape with the shape of the nucleus of an atom, with all the electrons and protons running in a spherical path around the nucleus."

CIRCLES WITHIN CIRCLES

Sternbach built a series of models that showed two or more hoops at angles to one another. Elements from other, earlier rejected designs were saved and turned into a central core. "We had a number of key elements that were retained from the very beginning of the design process," he says. "Even the oil platform had something of a central core. We knew that we had to have an Ops module or tower of some sort. We knew that we had to have a promenade. I sort of assumed that we would have something of a central power generating facility and all of these central elements began to stack one on top of the other."

Before long, Sternbach had produced a design that showed promise. Okuda recalls that when Berman saw the design, he added a crucial element. "I remember Rick Berman calling and saying, 'I just had an epiphany – let's break the tops and bottoms of the hoops.' That's how we ended up with the top and bottom docking arms."

"When we cut the tops and bottoms off," Zimmerman continues, "we found places to dock ships and we found a shape that was very pleasing to the eye."

At this point, Joe Hodges, who had been working on the interior sets, stepped in. "Eventually," he recalls, "we got to this ring thing, but unlike the interiors it was really Starfleety. I went home one evening with a render that Rick had done and traced over it using some of the shapes that we'd been working on. I did four pencil sketches, with all those curves, trying to give it a

▶ After Rick Berman suggested breaking the hoops to turn them into arms, Sternbach produced the render at the top. Joe Hodges then sketched over it, modifying the shapes so they looked closer like the designs that he and Nathan Crowley were working on for the interiors.

▲ Hodges and Crowley's design for the interiors (as illustrated by Jim Martin, right) were a continuation of the work they had done on 'Dracula' (left), which was inspired by the work of Carlo Bugatti.

▼ The design work that Hodges and Crowley had performed on elements such as the windows and spires on the promenade was carried over to the station exterior.

concentric rings that are joined by three arms and then we have three weapons towers/docking arms that are off of the final ring, the cargo ring."

Each of these separate elements added up to nine, which made perfect sense for a station called Deep Space 9. As an aside, Hodges says, the station's name was originally inspired by Michael Piller's love of baseball, and the number nine was based on the number of fielding positions on a baseball pitch. In summary, Zimmerman says that the final design was a combination of the nucleus of an atom, a Mercedes emblem, and a gyroscope.

Sternbach concentrated on the practicalities of the station's design, going over it to make sure it had all the technology it needed, both to appear as a functioning space station and to serve the needs of the scripts that Piller's writers' room was turning out.

"We knew they were getting Runabouts from Starfleet and they had to be housed somewhere, so we found places to garage them. Your typical viewer is really not going to dissect the station just by looking at it, but I developed a number of small but important details that had to be there. It was a fun project to be able to peg certain systems to certain shapes. We know that there is a defensive shield system on the station, so I designed a series of little devices to make the shields. I worked up the fusion generators down in the basement.

more alien shape. I showed them to Herman and he went for it."

CARDASSIAN DESIGN

At this point, Hodges introduced elements of Cardassian architecture that Zimmerman had been developing, in particular, the idea that Cardassians liked things in threes. In Sternbach's render of the inner ring had been connected to the outer ring by two horizontal arms. Hodges added a third. As a result, if you observe the station from the top, it resembles the Mercedes symbol.

"The Mercedes emblem is quite important design-wise," Zimmerman says. "We have three

▲ Delgado produced
a series of sketches
that explored what the
unusual surface texture
might look like.

We worked out places where the ships could dock. We refined a lot of the weapons systems. We found places for phaser emitters and photon torpedo launchers. For the most part, we imagined that the Cardassians had either trashed or removed all their important defense secrets, so all of the new systems had to be adapted to work with Starfleet equipment. We worked all of that into the design."

By the time the blueprints for the model makers reached the art department, Hodges and Crowley were concerned that it had become a little too much like a conventional Starfleet station design. "I remember the day the drawings were going out to the model shop," Hodges says. "Everything seemed to look very Starfleety again. I was so frustrated. We were adamant that there should be a link between the outside of the station and the inside. That's why we were passionate about adding that detail. It was two A1 sheets. We took

one of the drawings and put it on the wall and Nathan and I scribbled all over it with big black markers. We basically took all of the detail Nathan had put into the balustrades, all the detail we had put into the windows and added that to the outside. We were able to meld the two. Then we went to Herman and said, 'Please, can we just go back to this.'"

Zimmerman looked at what they had produced and could see the value in it. The three months he had started out with had shrunk right down so there was barely any time left. Nevertheless, he took the drawings and went to see Berman.

"I remember being in Rick's office and literally going down on my knees and saying to him, don't go with the Starfleet exterior treatment. Let me give you a better way to go, and showing him something that Ricardo and the two English designers had worked out. Rick saw the beauty of it and agreed to do it. But had I not pressed the

◀ This Delgado sketch shows one of the 'sails' in detail. His approach involved subtly raising and depressing different sections. This meant that when seen from a distance, the station looked relatively simple and smooth, but as you got closer it became more and more complex as you began to see the different shapes.

issue, the station's exterior might have looked more Starfleet than Cardassian. I'm proud of myself for having had the guts to go there, and proud of Rick for having seen the advantage of going one step further and making it more gritty, more dark and more alien than perhaps even he had wanted in the beginning."

Ricardo Delgado stepped in and started to add the kind of surface detail that Hodges and, in particular, Crowley, had been adding to their designs for the station's interior.

"Rick's design was nearly there," Delgado remembers. "I'd say it was 90% done – then I did an 'alien technology' pass over the whole thing. I remember Rick showing his renderings and Herman weighing in, as he should have. I took Rick's near-final design and rendered some alien-looking textures on top of it, particularly on the outer rim. My pass was more in the details, taking away the Starfleet aspect of the design a bit and introducing the presence of alien engineering and design.

UNUSUAL SURFACES

"A lot of the interior design elements came from Joe and Nathan," continues Delgado. "I took their shape language ideas and incorporated them into my set sketches. I carried that over into the exterior. Looking back on it, I perhaps was able to take all that great work around me and tie it together.

"I was inspired by two other ships: the Derelict Ship in 'Alien,' as well as the NTI base in 'The Abyss.' I felt like those two designs successfully mixed large sweeps with 'greebles', the VFX term for model kit bits pasted onto recesses of a model to give the design scale, texture and visual interest. It's a tricky thing to make an exterior design match the interior sets in texture and design, but *DS9* does that well, in my opinion."

Hodges says that a lot of the detail he and Crowley had introduced on the interior was a continuation of the work they had created on 'Dracula', which in itself was inspired by the work of Italian furniture designer Carlo Bugatti. "On 'Dracula' we were designing Lucy's bedroom. The set decorator came in and brought us this book of

◄ Sternbach produced
the final sketch for
the station, which
incorporated all the work
that Hodges, Crowley
and Delgado had done
on the surface detail, and
integrated with all his
earlier work.

Bugatti furniture and it just blew us away. I think that must have gone with us. If you look at it, it would be very at home on Bajor."

Herman Zimmerman adds that Delgado was also inspired by the Cardassian costumes, which had been designed by Robert Blackman, and Michael Westmore's makeup.

"Ricardo came up with some wonderful shapes that I wouldn't have thought of, probably most designers wouldn't have," he says. "He depressed the surfaces of the basic shape of things and put all the equipment slightly below. That means that instead of having a station that was either very slick and sleek and beautiful on the outside, or a station that was all tank parts and machinery, it was a combination of the two. It's a slick exterior from a distance and the closer you get, the more texture is laid upon it. He came up with some wonderful surface ornament that was based on Bob Blackman's costumes for the Cardassians, and on Michael Westmore's makeup for them. Both of them had been seen in *TNG*, but Cardassia was

kind of an unknown, and we made it up as we went along. We evolved the language of Cardassian design by extrapolating from those makeup and costume hints."

The revised drawings went to Tony Meininger's workshop, who returned an extraordinarily detailed model. "We got an incredibly beautiful model made by Brazil Foundation in Glendale," Zimmerman says. "He is a really skillful model maker. This six-foot diameter model of the Deep Space 9 station is what you see on the air every week, and it is exquisite. It's the best model I have ever seen."

Everyone who contributed to the design looks back on it with immense pride, recognizing that the station combined the best aspects of all of their work. " I think," Zimmerman says, "we ended up creating something quite unusual. It's an honest kind of design which I think fits the Cardassian profile. It's not something that 20th century Earth people would probably have designed, it is bizarre, it's whimsical and it's artistic."

STAR TREK
DEEP SPACE NINE
"THE WAY OF THE WARRIOR"

ARRAYS DEPLOYED

UPPER DEFENCE MAST

PHASER EMISSIONS
PLATE (SHIELDED)

LOWER DEFENCE MAST John Eaves 7/95

DOCKING PYLON (UPPER/LOWER) PHASER ARRAYS

PHASER EMITTER EXTENDED

DOOR OPENS

SHIELD DOOR RUNNERS

OMNI DIRECTIONAL FIXED PHASER ARRAY
(WITH DUEL ACTION DISRUPTER SWITCH OVER!)

ARMING

DEEP SPACE 9

For one of his first assignments, concept artist John Eaves was tasked with fitting Deep Space 9 with an arsenal of hidden weapons.

When John Eaves joined the *DEEP SPACE NINE* art department in 1995, it was a time of war. The Dominion had emerged as a prime threat, and the politics of the Alpha Quadrant had been thrown into chaos. Space battles had always been a part of *STAR TREK* but now they were front and center as Ira Steven Behr and the writing staff pushed the show into darker territory. Eaves' arrival at the beginning of the

show's fourth season coincided with this new direction. Appropriately, one of the first jobs he was assigned involved upgrading Deep Space 9's weaponry so it could face off with the Klingons in season opener, 'The Way of the Warrior.'

As Eaves explains, when the station had been designed, no-one had been too concerned about arming it. "There are some curved parts on the inner ring that kind of mimic the larger pylons.

▲ Eaves had to find places on the station where he could reveal new weapons that were hidden behind existing details.

▼ Eaves found existing shapes on the station that he could manipulate to turn them into doors and panels that opened to reveal weapons that were hidden behind them.

John EAVES 7/95 DS9. WEAPONS ALTERATIONS Docking PYLON PHASER ARRAY

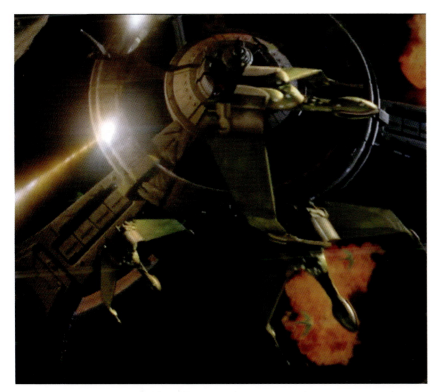

▲ In 'The Way of the Warrior,' the Klingons set out to invade Cardassia. When Sisko offers the new Cardassian government refuge, the Klingons attack Deep Space 9 only to discover the station has had a massive weapons upgrade.

Those were the original little defense arrays. As best as I can recall, they never actually fired them. When I got there, they wanted a big battle and those sails were too small to do what they wanted to do."

Eaves' boss, production designer Herman Zimmerman, tasked him with working out how to retrofit weapons to the station. "Herman didn't give me much guidance. He said, 'Here's the station. There's going to be a big attack and they want a fight. Do the armaments.'"

The challenge for Eaves was that he had to add weapons without altering the model. At the time almost all the visual effects were created using physical models, and altering the model of the station would have been impractical. It had already been filmed many times and the VFX crew relied on stock footage of it that wouldn't have matched an upgraded version. So Eaves' task was to find places where he could conceal weapons that would pop out when they were needed.

"They didn't alter the giant space station model, they just made insert pieces," he says. "I had to

DEFENCE SAIL (INNER RING)

RINGED PHASER PLATES (SHORT RANGE) DISPURSMENT

MONITOR EXTENDS

4 PLATES (BOTH SIDE OF SAIL)

EMMITTER

DOOR

DOCKING AIRLOCK

LOWER DOOR

DOCKING UPPER PYLON (REPEAT DETAIL ON LOWER)

(HEAVY) LONG RANGE PHASER BLAST PORT

(HEAVY) LONG RANGE PHASER BLAST PORT (CONVI DING)

John Eaves 7-95
ARMAMENT DETAIL - DS9

STAR TREK
DEEP SPACE NINE

▲ Eaves worked with Mike Okuda to find places on the station where he could add concealed weapons. He subtly modified the shapes on the station's exterior to turn them into doors.

▶ The sails on the inner ring were always intended to house weapons, but Eaves added to them, giving them forward-mounted phaser arrays and torpedo launchers and a circular weapon that popped out of the side and rotated.

work out what they would look like and find places I could hide them. I manipulated the cut lines on the surface of the station to turn them into doors with concealed weapons behind them. The existing design really lent itself to that. Because of the way the panels had been designed, it was easy to turn them into separation lines and door

hatches. It worked out a lot better than I thought it would."

Eaves admits that at the time, he wasn't that familiar with the design of the station, so he turned to scenic art supervisor Michael Okuda for help. "Mike knew all about the technical layout of the station. I'd look at his drawings and say, 'What about putting some weapons there?' I didn't know where the runabout bays were on the inner ring, so he showed me that so I could work around them. We realized I could put stuff on the towers. Mike showed me where the docking clamps were so I didn't disturb anything that had already been identified."

Eaves also talked to the VFX team to ask them if they had any guidance, "They said, 'Don't make too many! That was because they'd have to show them firing all the time, which would have made their lives harder."

Eaves came up with three different sets of weapons, which he says were inspired by Herman

LOWERED POSITION SHOWN WITH INDICATION OF DOOR OPENING

(DUEL PHASER) OMNI DIRECTIONAL DISRUPTER
[ELEVETED POSITION]

RUNABOUT DOCKING PORT

PHASER BATTERY LOCATIONS

DEFENCE BAYS

INNER RING "NEW" PHASER

John Eaves 7/95

STAR TREK
DEEP SPACE NINE
"THE WAY OF THE WARRIOR"

▲▼ The design of the phaser arrays on the inner ring
went through several changes, with Eaves' original
concepts being rejected because they looked too big.

LOWERED POSITION SHOWN WITH INDICATION OF DOOR OPENING

(DUEL PHASER) OMNI DIRECTIONAL DISRUPTER
[ELEVETED POSITION]

RUNABOUT DOCKING PORT

PHASER BATTERY LOCATIONS

DEFENCE BAYS

INNER RING "NEW" PHASER

John Eaves 7/95

STAR TREK
DEEP SPACE NINE
"THE WAY OF THE WARRIOR"

▲ The phasers were designed to pop up from the inner ring, in the areas between the landing bays that were used by the runabouts.

Zimmerman's original idea that all Cardassian designs were broken up into threes.

"There are three areas with one or two weapons in each. There are two above the ring, and two below the ring. Then there's one at the top of the towers and one in the center of the towers, where

the big outer ring goes. I think each spire would have four guns on it. That was about it."

At the top of the sails Eaves decided to have the corner that faced into the station slide apart to reveal a phaser emitter underneath. "There were weapons at the top of the spires. I designed a

▲ Eaves describes these weapons arrays as "bread baskets." Like all the other new weapons they were made as separate sections of model.

▲ These weapons arrays were fitted to the pylons just above and below the point where they meet the station's outer ring.

version where it bends round the corner so it can fire horizontally and vertically, but I think in the end they just used a flat one." Eaves made the original defensive sails on the inner ring more powerful by having circular phaser emitters pop out from the side. In the show they spin around, firing in different directions. Eaves was delighted with the effect, but explains the idea came from the VFX team rather than the art department. "It was an effects decision to make the whole thing roll and fire out of little, precise areas. When we turned the drawings into the meeting everyone had a little input. I'm used to the big phaser rings on the ships, where it's just a static emitting surface and the beam can fire from anywhere. At the meeting they saw the drawing and assumed that it rolled. I thought, 'Well that's kind of a neat idea and it gives a little motion to it too.'"

The front faces of the sails had never been shown in close-up and were now revealed to have phaser emitters on the front. The bays between the runabout landing pads slid open so that weapons arrays could pop up. Eaves recalls that the design of those went through some changes. "It was

mostly a scale problem. The first one that I designed kind of had a radar dish look to it, with two guns on it. It was real big and chunky and it was too big for the scale. We just funneled it back down to match the ones I had already done on the pylon. Also, they wanted everything to look as if it belonged together so they all ended up with this shape, kind of like a bread basket."

To Eaves' surprise, his weapons arrays fired photon torpedoes as well. "The effects guys could have photon torpedoes firing without showing exactly where they were coming from, so I didn't design any torpedo launchers. But on those bread baskets there's a little section right in the center, kind of a detail, like a diamond shape. When the effects team saw that they said, 'Ooh, we could use this for a torpedo launcher.'"

The finished result with the Cardassian orbital weapons platform was an even more heavily armed station than Eaves had imagined. The whole process was finished in a matter of weeks and Eaves didn't stop to think about the significance of his first work on a STAR TREK TV show – or how much it would change his life.

◄ The final design for the weapons arrays on the inner ring was simpler and smaller than Eaves' original concepts and the design was altered to look more like the arrays at the base of the pylons.

LIVING QUARTERS POD

STARFLEET NACELLES

DESIGNING THE
RUNABOUT

DEEP SPACE NINE's runabouts gave illustrator Jim Martin his first chance to design a ship for *STAR TREK*.

When Michael Piller and Rick Berman came up with the concept for *STAR TREK: DEEP SPACE NINE* they had the idea that aliens would come to the station, bringing their stories with them. As a result, the Starfleet crew would have no need of a spaceship. They did, however, decide to provide them with some small craft that could be used to travel to other planets and make forays into the Gamma Quadrant. The series bible described these runabouts as "mid-sized... patrol ships" that are about 20 meters long, and have a crew of two, though they can be operated by a single pilot. It goes on to say that they provide cramped

REACTOR

RUNABOUT CONCEPT #2

7/92

DETATCHABLE
FLIGHT POD

DETATCHABLE
CARGO POD

DOOR DETAIL
SAME AS SET

▲ The final design that was submitted to the producers was drawn by Jim Martin, but was the result of a collaboration between Martin, Rick Sternbach and set designer Joe Hodges, under the guidance of production designer Herman Zimmerman.

sleeping quarters for six people and that there is a meeting and dining room off the cockpit.

REJECTED OPTION
As senior illustrator Rick Sternbach remembers, the first thought the team had was that they could reuse the design for the executive shuttle that John Goodson had built for *STAR TREK VI.* "This model was an updated version of the original series shuttlecraft *Galileo,* with recognizable elements

such as the forward windows, aft grille, protruding winglets, and side-opening doors." He further outlined that the same model had been adapted to become the *Sydney-class U.S.S. Jenolan,* Scotty's ship in *TNG:* 'Relics.'

However, before long, the producers decided that they wanted a fresh design. At the time Sternbach was still working in the *STAR TREK: THE NEXT GENERATION* art department, but contributing designs to the *DS9* art department,

DS9.
RUNABOUT

NCC-65471

DS9 RUNABOUT 03

CITY OF NEW ORLEANS

65471

Sternbach 6-92

▲ The producers originally considered using the model of the executive shuttle, which had been modified to become a medium-sized transport for the *TNG* episode 'Relics,' when it had gained a pair of warp nacelles. The idea was rapidly abandoned, but the shape of the model influenced many of Rick Sternbach's early runabout concepts.

which was being headed up by Herman Zimmerman in a separate building.

Sternbach produced a series of drawings that took Goodson's ship as an inspiration. He bulked up the rear section of the ship to accommodate the living and meeting quarters that the series bible called for. "My earliest drawings reflect the major structural elements of his ship," he recalls, "in particular the forward windows, side windows, and entry doors. These would be the first pieces 'frozen' in the design process, since the cockpit set had to be finished and filmed before the miniature was completed."

When these early drawings arrived in the *DS9* art department, the feeling was that they were too "wedge like." Sternbach remembers that word also came back from the producers that the runabouts

DS9.
RUNABOUT #2

Sternbach 6·92

should have more prominent nacelles to make them instantly identifiable as Starfleet vessels.

Around this time he produced a series of drawings that extended the body of the vessel and reintroduced nacelles, which he suggested could be attached in a variety of different ways.

MODULAR DESIGN

Meanwhile, the *DEEP SPACE NINE* art department pursued a different direction. Jim Martin, who at that point was the art department's PA, picks up the story: "Rick was the lead illustrator working on both shows," Martin explains. "He started by doing some wedge-shaped ships. When they got to our art department, one of our set designers, Joe Hodges, wanted to do something different. He sketched out the concept of a forward module for

the pilots, a spaceframe holding the nacelles, and another module in the back."

As part of discussions over the runabout, the team started talking about the design of the Eagle transporters from Gerry Anderson's 1970s science-fiction drama 'Space 1999,' which also had a frame that could carried different modules.

Martin was an aspiring concept artist who would later become the show's lead illustrator. The runabout would be the first ship he would play a major role in designing for *STAR TREK*. "I asked if I could do some designs based on Joe's drawing," he recalls. "Herman, being a kind and generous boss, let me, as the art department PA, expand on Joe's original idea and see what I could do with it."

Martin rapidly produced a color sketch that did exactly that. His version of the design consisted of

 ▲ Sternbach's earliest designs show very wedge-shaped ships that resemble large shuttles. This wasn't exactly what Zimmerman and the producers were looking for, so Sternbach was asked to produce some alternatives that could immediately be identified as Starfleet ships.

Pylon plus "AWACS" pod

sternbach
6-92

Overwing + Nacelles

sternbach
6-92

Annular Wing Engine

sternbach
6-92

65243

DEEP SPACE NINE

CITY OF NEW ORLEANS

DEEP SPACE NINE

◀ The bible describes the
runabouts as a symbol of
the Federation's presence
in the Bajoran system, and
the producers were keen to
show recognizable
warp nacelles.

a frame with a backbone that supported twin
warp nacelles, a compact forward cabin that
resembled a larger version of the standard shuttles,
and an interchangeable rear module.

AWKWARD SHAPES

As he sketched, he found it particularly difficult to
work out the best shape for the frame that held the
different components, and how to attach the
nacelles. "The pinch at the top of the arm that
holds the top of the nacelles was a tough one.
I remember thinking, 'How do I make this look

good?,' so I did some additional passes to try to
figure out the design."

Martin tried putting a platform under the
nacelles that supported them at a right angle to
the frame, and giving the pylons a more angular
shape. As he worked on these designs, he started
to slim the different modules in the middle down,
making them more streamlined.

Excited that he had been given the chance
to design a new ship, Martin also produced some
alternative designs that had nothing to do with
the design direction that Hodges had started.

COMMAND POD
DETATCHES
FROM ENGINES

▲ Set designer Joe Hodges suggested that the runabout could have a framework that supported a variety of different modules that could be used for different missions. He produced a simple sketch that showed the idea. Jim Martin, who was a PA at the time, lobbied Zimmerman for the chance to develop the design further, which led to this sketch.

WARP FRAME

NTER-CHANGEABLE
ARGO-POD

RUNABOUT

Structural Spine + Warp Engine

Ward Nacelle

Swapable Cargo Module

Flight Deck + Wardroom

Sternbach
7·92

◀ Sternbach continued to be involved with the design process and produced more drawings that incorporated Hodges' suggestions.

◀ Because Jim Martin was excited to be given a chance to design a ship, he threw out some alternatives, in case there was something that caught Zimmerman's eye.

NCC- 67010

▼ Sternbach and Martin worked together to finalize the details on the ship's exterior, making sure it had all the necessary hardware.

▼ Martin also produced drawings that showed the interior of the runabout. This shows the layout of the cockpit, which would fit inside all the designs that the team produced.

pushed the two modules Hodges had suggested further up the frame.

One of the biggest problems Sternbach could see was where to locate the runabout's impulse engines. In Martin's drawings he had placed a module on the top of the frame to the back of

the ship. Working together, the two illustrators came up with a different way of solving the problem that also addressed Martin's concerns over the shape of the nacelle pylons.

"The intakes and exhaust nozzles could have been stuck on or embedded in a thick pylon,"

Sternbach explains, "but the better location turned out to be under a thinner, more aesthetically pleasing wing. With the impulse grilles set back, the wing retained its proportions, and the mass of the impulse system filled in an empty volume that might otherwise have made the runabout appear to be a flapping bird."

ESSENTIAL SYSTEMS

Sternbach goes on to say that the two illustrators also addressed the position of all the other systems that the ship was going to need. "The 'pancake' warp reactor was placed atop the backbone, with its matter and antimatter tankage and injectors. The pylons had a few areas trimmed out and were given phaser strips, plasma conduits, and interesting plating, again part of the use of texture to convey scale. The command section, which we now imagined as an escape craft with its own limited propulsion system, had its nose streamlined. Sensor strips, transporter emitters, and additional phasers were also spotted around."

Martin remembers that as the ship evolved, the different elements that Hodges had suggested became more and more streamlined. They were blended together to the point where they could barely be distinguished from one another. "Joe had initially done a frame holding components, but as we worked on it, it evolved into more of a unibody design. "

Eventually, working under Sternbach's supervision, Martin produced a yellow sketch that showed an almost final version of the ship. Zimmerman presented this to the producers, where it was approved. Sternbach now produced a set of plans for the modelmakers, refining the design even further as he did so. In particular he moved the nacelles lower so that they rested on the ground, making the model look more natural when it was sitting on the landing pads.

Ultimately, Hodges' idea that the ship would consist of a frame supporting different modules was never used in any episode. For his own amusement, Martin produced a pair of sketches, which showed how the different components could fit together. By this stage, the runabout was conceived as having three distinct modules: a command pod that contained the flight controls,

▲ Martin also worked up this drawing, which shows the rear compartment of the runabout. The distinctive windows instantly establish the scale and location of the room.

WARP SLED

STEM MISSION ROOM

▶ This Jim Martin drawing shows how the different modules of the runabout connected to one another, with a central corridor running through the warp sled.

COMMAND POD

CONNECTING TUNNEL

CARGO MODULE

and could be ejected like a smaller shuttle; a warp sled that formed the backbone of the ship, with a 'mission room' placed at the back; and finally, an interchangeable cargo module. This last part was U-shaped and fitted around a corridor that ran through the middle of the warp sled, connecting

all the different modules to one another. This, of course, was never actually shown on screen. "It was," Martin smiles, "just an idea."

Martin was also responsible for producing concept drawings that showed the inside of the cockpit and the rear module, which he worked on

▶ The idea that the runabout would consist of different modules came from the art department, but was never used by the series' writers.

WARP SLED

COMMAND POD

STAR TREK
DEEP SPACE NINE
RUNABOUT
Exploded View
J. Martin 10/7/93
©1993 Paramount Pictures.
All Rights Reserved.

with Joe Hodges. He remembers that the goal was to make sure that the sets obviously belonged inside the model. "We were trying to rationalize what the interior might look like if it lined up with what we had done for the exterior. I remember that certain things were a given: for example, we knew what kind of chairs we were going to use,

which had this cladding on the outside to make them look suitably Starfleet."

The task of building the filming miniature fell to Tony Meininger and his model company, Brazil Fabrications, who were also building the model of Deep Space 9 itself. The runabout model they produced was 19.5 inches long. Meininger also constructed a model of the landing pad that was in scale with the model of the runabout, rather than the station itself.

In *DEEP SPACE NINE*'s second episode, 'Past Prologue,' the script called for two runabouts, one operated by Kira and the Bajoran terrorist Tahna Los, the other by Sisko and O'Brien. In order to make it clear which was which, the producers asked Sternbach to design a sensor pod that could be added to the top of Sisko's ship. The design he came up with could be removed, and featured in eight episodes in total.

A CG version of the ship was eventually built by Digital Muse, who scaled it out to be 18.3 meters long. The original motion control model was sold at auction for a remarkable $33,600.

▲ The sensor pod was an optional extra that was designed to avoid confusion when an episode featured two different runabouts.

▲ One of Jim Martin's earlier concepts for the *Defiant* envisioned it as a halfway point between a fully-fledged starship and a Runabout.

U.S.S. DEFIANT

The design of the *U.S.S. Defiant* started off as a 'beefed-up' Runabout, but evolved into a new shape that looked both fast and aggressive.

When Ira Steven Behr took over as executive producer and show runner at the beginning of season three of *STAR TREK: DEEP SPACE NINE*, he decided to pick up the action level of the show and include more hard-hitting, exciting battle sequences. The Dominion had been introduced as the show's villains, but the protagonists on Deep Space 9 were lacking in a suitably powerful weapon with which to fight their new enemy.

As Behr explained, "We had all these plans for the Dominion... and what were we going to go after them with? Shuttlecraft?! It just seemed ridiculous."

A new, more powerful starship that could match the threat of the Dominion was required. This would give the writers an opportunity for more direct conflict. The task of envisioning this new Starfleet vessel fell to illustrator Jim Martin, who was working under production designer Herman Zimmerman.

The brief stipulated that the ship could not look like any other class of Starfleet ship seen in the franchise previously. The art team was also told that it should be small, but so powerful and scary that no one would mess with it. Martin began by working on designs that looked like 'beefed-up' Starfleet Runabouts.

These early designs – when the ship was known as the *U.S.S. Valiant* – were rejected by the producers, so Martin sought a new concept that was more

BRIDGE

RAM SCOOP

PHOTON BAY

USS VALIANT

▲ This early concept had some elements, like the 'nose' of the ship and the recessed bridge that would end up in the final design.

▶ This design was another that looked as if it was based on a runabout, while also having some recognizable full-size starship elements, such as the warp nacelles. Ultimately, the producers wanted it to look more impressive.

of a cross between a starship and a Runabout, but this was rejected too.

Ultimately, the design the producers chose came about by chance. "Working on the show, you have a lot of ships of the week," explained Martin. "A new race is coming to the station so you do a new space ship design to accommodate them. The *Defiant* started as one of these ships of the week. It was an illustration I had done, I think, as a cargo ship and it was kind of a sporty thing. We threw it in with three or four other drawings and submitted them to (executive producer) Rick Berman and that

was it. He keyed in on that and we started tweaking it from there."

These concept illustrations were then passed to STAR TREK modelmaker Tony Meininger, who worked with visual effects supervisor Gary Hutzel, to refine the look further. As Hutzel explained: "We went to Tony Meininger and I said to him that it's got to have speed – it has to look fast."

Taking inspiration from exotic sports cars, Meininger added additional design elements that completed the final look.

Everyone was pleased with the final result; Jim Martin recalled: "That was my favorite thing to draw for the show. It's like a sports car, very compact and contained in a shell. We joked in that it was the 'Battle Turtle.'"

FRONT

TOP

BRIDGE

IMPULSE ENGINES

SCALE

WEAPONS

NCC-6089
U.S.S. VALIANT

RAM SCOOP

WARP ENGINES

△ The producers chose a design close to this version. Originally, Jim Martin had planned to use the design for a Maquis fighter.

USS VALIANT MARTIN

◀ The 'Maquis fighter' design was refined further, so it looked sleeker and more recognzably of Starfleet origin. Initially, the *Defiant* was going to be called the *U.S.S. Valiant*, hence the markings on the illustration.

WEAPONS MODULE

WARP COWLING

NAV DEFLECTOR / SENSOR

TOP VIEW

USS DEFIANT CONCEPT SKETCH

JIM MARTIN~

▲▶ Once the basic approach to the design had been agreed upon, Jim Martin produced the above sketch. This shows the completed design for the *Defiant,* including his call outs, identifying the warp nacelles, deflector and weapons pods, most of which had a different design to the ones on conventional Starfleet vessels. He also created the fully-colored version on the right.

The producer and writer Ronald D. Moore was given the task of 'inventing' the capabilities and features of the *Defiant*. Originally he wanted to call the ship the *Valiant,* but he was told he could not name it with anything beginning with 'V' as *STAR TREK: VOYAGER* was about to debut and no-one wanted two shows that starred ships beginning with the same letter.

DATA FEED

Production illustrator Jim Martin's first professional job after leaving university was on *DEEP SPACE NINE.* He went on to work on the pilot of *STAR TREK: VOYAGER, STAR TREK GENERATIONS* and *STAR TREK: ENTERPRISE.* Apart from designing the *Defiant,* his other *STAR TREK* creations include the Bajoran lightship and the Jem'hadar fighter. After leaving *STAR TREK* in 1995, Martin became a freelance production illustrator and has worked on many blockbuster movies, including *Alien: Resurrection* (1997), *Spider-Man* (2002), *The Matrix Reloaded* (2003), *Captain America: The First Avenger* (2011) and *Oblivion* (2013).

DESIGNING THE

▲ The first ship that Jim Martin designed in his role as *DEEP SPACE NINE* resident illustrator was the Bajoran raider, and his concept also included this drawing of the cramped interior.

BAJORAN RAIDER

Illustrator Jim Martin joined *STAR TREK: DEEP SPACE NINE* as a PA, but he was soon promoted and set about designing the Bajoran raider.

J im Martin remembers the Bajoran raider because it was the first ship he designed solo after he was made the resident illustrator on *STAR TREK: DEEP SPACE NINE* in 1993. Martin had started his career on the show as a PA to production designer Herman Zimmerman and his staff. During this time, he learned about the art department from the ground up, but was also given the opportunity to express his opinions and submit his own designs. "It was a really friendly art department," said Martin. "You could participate in any discussion you wanted to about what something should be. That was really something to enjoy. There were no egos. Everyone from Herman to Mike Okuda (scenic art supervisor) to Randy McIlvain (art director) was really cool about sharing the experience. When I did get a chance to work on a feature of the show, like the runabouts or some medical stuff for sickbay, I had an idea where we were coming from with the design."

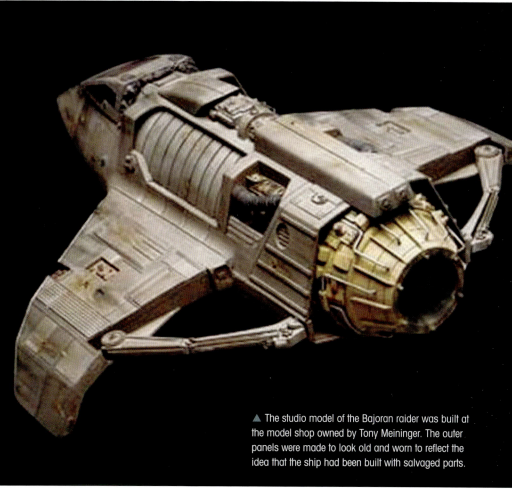

▲ The studio model of the Bajoran raider was built at the model shop owned by Tony Meininger. The outer panels were made to look old and worn to reflect the idea that the ship had been built with salvaged parts.

After Martin had been in the department for around a year, *DEEP SPACE NINE*'s resident illustrator, Ricardo Delgado, left, and with the backing of Zimmerman, Martin took his place.

"It was a little frightening at first," says Martin. "I remember the first prop I had to draw where I felt solely responsible. Of course, that wasn't really true because there's a lot of input in the art department, from Mike Okuda, from Herman, from everybody; it was a Cardassian field generator device."

FIRST SHIP DESIGN

It was not long into season two of *DEEP SPACE NINE* that Martin was asked to design his first ship as a solo project for 'The Siege.'

"I did a Bajoran fighter that Kira and Dax crash," says Martin. "I remember being excited about that. There were a few ships in that episode; there was a Bajoran transport and a Bajoran fighter.

"I remember something really ridiculous about that ship. We intended to re-use these old windows that we had found for the set of the interior, so the windows I designed for the exterior had to match. I kept trying to come up with a way to incorporate the window frames into the ship design. Then we ended up not using them, but they were still on the miniature."

Martin's design illustrations were then sent to Tony Meininger's model shop, Brazil-Fabrication & Design, where it was converted into a physical studio model. It was constructed out of styrene and resin and measured approximately 18x15½ inches. It made its debut in 'The Siege' and was later used as a Maquis ship in the *STAR TREK: THE NEXT GENERATION* episode 'Preemptive

Strike,' where it was slightly modified around the cockpit canopy area. The model was sold in 2006 as part of the 40 Years of *STAR TREK*: The Collection auction, with the winning bid coming in at $5,760.

In 1998, the studio model was translated into a CG model for an appearance in the background of the season seven episode 'Shadows and Symbols.'

▲ While mostly faithful, Jim Martin's original concept for the raider featured a more pointed nose than that incorporated in the final model.

► The Bajoran Transport was designed for the second season episode *The Siege*. Its designer, Jim Martin, had worked on *DS9* since the beginning but this was one of his first jobs after he was promoted to illustrator.

DESIGNING THE 'BAJORAN
TRANSPORT'

Alongside the Bajoran raider, a second Bajoran ship formed part of Jim Martin's earliest work as *DS9*'s newly minted concept artist.

Once he was installed as *DEEP SPACE NINE*'s resident illustrator at the beginning of season two, Jim Martin wasted no time getting stuck in to his first assignments. His first assignment involved a pair of Bajoran ships that were needed for the three-part story that would open the season: 'The Homecoming,' 'The Circle,' and 'The Siege.'

"(Production designer) Herman Zimmerman came back from the script meeting with a list of his needs for the coming episode," recalls Martin. "I needed to design two Bajoran ships:

▶ The transport was designed at the same time as a smaller Bajoran ship - the Raider - which was flown by Kira and Dax. Martin worked on the two ships together, making sure they would have design elements in common.

◀ The design for the Bajoran Transport came together very quickly but the Raider went through several passes before Martin arrived at the final design.

there was a small ship, 'Kira's Raider,' and a large transport ship."

Perhaps surprisingly, Martin had very little to go on – a year in to the show and a Bajoran ship had not been seen on screen. "These were the first Bajoran ships done for *DS9*," he remembers, "so there wasn't an established ship style to follow. Herman had me look at the

Bajoran architecture we had done for previous episodes, and also the Bajoran symbols to help me get a flavor for what the Bajoran ship aesthetic might be. We talked about graceful sweeping wings and Bajoran shape language."

LINKED BUT DIFFERENT
Martin had a week to come up with his

ship concepts before they would be shown to the producers. He designed the two ships together, ensuring that they would have a lot in common, implying that they were produced by the same culture. At the same time they had to be clearly different.

"Both designs were due that week and were submitted together at the

▲▶ Once the design had been approved, based on the three-quarter view, Martin produced a series of detailed plan views.

wings were short and stubby, whereas for the transport they were wide and sweeping, like a bird of prey.

"I remember that for the transport Herman wanted something graceful in keeping with the Bajoran design aesthetic," Martin says. "I worked up a three-quarter view, which we took to the production meeting. Sometimes ships or props would be approved in a single meeting, and this time we got lucky. I remember that the Bajoran transport was approved in the initial design pass and didn't need further exploration, though Kira's raider did have a couple of design passes before it got the go ahead."

MAKING IT REAL
Now he had an approved design, Martin returned to the art department and produced a set of elevations that would be handed over to the VFX team, who worked with Tony Meininger's model shop, Brazil Fabrications & Design. As the model was built, Martin's design was refined, with a significant change being made to the design of the front part of the wings.

"The art department had an amazing relationship with Tony Meininger and the model shop," says Martin. "They did great work and always brought their craft and know-how to the ships. So the final design was usually a wonderful collaboration. I always enjoyed seeing the final model when the effects were being shot. That's a reward as an illustrator: to see the realization of a design you began. Sketches and drawings are great starting points, but model builders know how to make the designs come alive."

The finished model made its debut in the season opener, 'The Siege'. This was rapidly followed up with an appearance in the *STAR TREK: THE NEXT GENERATION* episode 'Preemptive Strike' where it was shown as one of the

production meeting. Since I drew them back-to-back, I had the chance to think about them both at once.

"The Bajoran raider was meant to be an outdated fighter that Kira and Dax fly, and the transport was newer, more regal, meant to transport dignitaries like Kai Opaka. The script called for a large Bajoran ship, something bigger in scale than a runabout."

Martin began by producing a series of quick sketches, which Zimmerman commented on, approving a basic design direction that the artist could pursue. The design that Martin came up with was something of a departure for *STAR TREK* as neither of the ships had obvious warp nacelles. Instead they had conventional wings akin to modern aircraft. In the case of the fighter, the

◄ The practical model of the Bajoran Transport was constructed by Tony Meininger's model shop and made over 20 appearances on *DEEP SPACE NINE*.

◄ As the model was made, the design was refined. Most noticeably, the shape of the wings was simplified. Meininger's team also established the colour scheme for the ship.

◄ VFX house Digital Muse recreated the Bajoran Transport as a computer-generated model for an appearance in the episode *Shadows and Symbols*. Shots of the practical model also continued to appear on the show.

Maquis ships that was taking on the Cardassians. For story reasons, onscreen the scale of the ship varied massively – in 'The Siege' it is clearly a medium sized vessel, but in 'Preemptive Strike' it is only the size of a shuttle.

The physical model, which measured 27 inches across continued to be used throughout the remaining seasons of *DEEP SPACE NINE*. It was eventually rebuilt by Digital Muse as a CG model for the massive battle sequence in the season 7 episode 'Shadows and Symbols.' The ship was now referred to as a 'troop transport', and was scaled out to be 70 meters long. The physical model was sold at auction in 2006, when it fetched $4,500.

▲ Rick Sternbach's final concept drawing the *Galor* class, showing all the important surface details.

DESIGNING THE
GALOR CLASS

The *Galor* class became one of the most unusual designs for a starship after illustrator Rick Sternbach turned to the Egyptians for inspiration.

While the Cardassians would become major antagonists of *STAR TREK: DEEP SPACE NINE*, they were first introduced in the *STAR TREK: THE NEXT GENERATION* episode 'The Wounded', where a new ship for this intriguing alien race was required. The task of designing that ship fell to senior illustrator Rick Sternbach.

Beginning the design process as he always did, Sternbach produced a series of very rough thumbnail sketches.

"I'll put together sketches just to give the producers something to start with," outlines Sternbach. "I don't want to give them too many finished drawings because there might be time lost if I'm going in a direction they don't like."

NEW DIRECTION

Once a sketch had been selected by the producers, Sternbach would work it up into a more detailed drawing, which was normally approved. Sometimes,

however, things were not quite so straightforward, and this design went through a major revolution.

"The original design direction for the *Galor*-class Cardassian ship was very bland, very pedestrian," adds Sternbach. "I really didn't have a good sense of who these people were or what the ship looked like. I did some quick 3D sketches on the computer, putting the Cardassian ship up against the *Enterprise*, and I wasn't really

▲ The studio model, built by Ed Miarecki and Tom Hudson followed Sternbach's design closely, although the modelmakers took the liberty of incorporating their initials into the panel work.

▶ Early in the design process, Rick Sternbach produced a series of simple 3D renders showing possible design directions. After his first designs fell short, he took inspiration from an Egyptian ankh and produced this version.

satisfied with what it turned out looking like. I turned the sketches in, and (producer) Peter Lauritson came back and said, 'Give us something really weird!'

"I said, 'OK, you want weird; I'll give you something weird.' So I went back to the 3D program, and started pushing and pulling shapes. We knew that the Cardassian makeup involved that sort of little elongated oval on the forehead, so I thought that was an interesting shape to play with. Somehow I made a mental connection with the Cardassians being like Egyptian pharaohs. After all, they had enslaved the Bajoran

population and taken over Bajor, so I thought perhaps something in that vein would work for me.

"I looked into the ankh symbol as a start for the shape of the ship. That eventually worked out with little bits and pieces of bridge module; the main body became a little bit streamlined; the tailpiece grew out of the ankh shape. Once the basic building blocks

of the body were done, the details fell right into place, right down to little tiny pyramids for the shipboard phasers.

"There was also, on the very top of the ship, something of a sacrificial altar, complete with giant urns. It was all done in ship hardware shapes, but the idea was to bring out some of that Egyptian feel. We even spec'd the ship out as being a desert yellow color with some

◀▼ The studio model of the *Galor* class featured a complex internal lighting system that illuminated the windows, engines and navigational deflector. The model was sold at auction in 2006 for $24,000.

cobalt blue accents and dark Chinese red, very much like the Tutankhamun sarcophagus. It was a departure from the familiar starship style, and I had a good time being steered away from the very straight Starfleet look."

The studio model of the *Galor*-class ship was built by Ed Miarecki and Tom Hudson at their model shop, Science Fiction Modelmaking Associates (SFMA). They had previously constructed props such as tricorders and medical scanners, used on *STAR TREK: THE NEXT GENERATION*, but the commission for the *Galor* class was by far the biggest they had undertaken for the franchise.

Miarecki and Hudson were enormously excited to win the contract to build the model, but then the enormity of the task hit home. They had just three weeks to complete the model and knew it would involve some very

long working hours. Rick Sternbach and scenic art supervisor Michael Okuda sent them fairly simple pencil plans of the ship, including color chips to show them what colors it should be painted.

INTRICATE MODEL

The construction was one of the most complex that the pair had ever undertaken, but it went largely without a hitch. The basic framework was made from aluminum and the model featured complex lighting circuits that made the impulse engines, windows, navigational deflector and navigational beacons light up. The final model ended up measuring 37 inches long, and according to Miarecki and Hudson, it had their initials 'EM' and 'TH', built into the detailing.

The *Galor*-class studio model ended up appearing in seven episodes of *THE*

NEXT GENERATION, 14 episodes of *DEEP SPACE NINE* and two episodes of *STAR TREK: VOYAGER*. It was sold at the '40 Years of *STAR TREK*: The Collection' auction in 2006 for $24,000.

For the last two seasons of *DEEP SPACE NINE*, the *Galor* class appeared as a computer-generated model. The physical model was sent to visual effects house Foundation Imaging as a reference for Brandon MacDougall, who built the CG model. He placed the physical model on a flatbed scanner to get an identical copy of the panel details and color that he could then use for the base 3D texture, ensuring an accurate reproduction of the model. The CG version of the *Galor* class made its debut in the *DEEP SPACE NINE* episode 'Sacrifice of Angels' and its last appearance was in the show's finale, 'What You Leave Behind.'

◄ The CG version of the *Galor* class was built at the effects house Foundation Imaging by Brandon MacDougall. Since that time it has been upgraded, making it suitable for use in print and capable of being used for HD broadcasts.

STAR TREK
VOYAGER

CARDASSIAN "DREADNOUGHT"
MATTER-ANTIMATTER STAND-OFF
WEAPON SYSTEM
16 NOV 95

PROPULSION SYSTEM RADIATOR (2)

ENTRY HATCH

SPECIAL (TECH) WEAPON EMITTER (2)

IMPULSE PROPULSION SYSTEM

MAIN NAVIGATIONAL SENSORS

PHASER EMITTERS

WARP PROPULSION SYSTEM

LATERAL SENSORS

MATTER-ANTIMATTER WEAPON HULL

COUNTERMEASURES LAUNCHER (2)

FORWARD ARMOR PLATES

PECIFICATIONS:

ENGTH: 78.6 FEET (23.9 METERS)*
PAN: 42.3 FEET (12.9 METERS)
EIGHT: 21.7 FEET (6.6 METERS)

LL DIMENSIONS APPROXIMATE

ASS (LOADED): 80,564 POUNDS (36,543 KILOGRAMS)
CLUDES 2,000 KILOGRAMS MATTER-ANTIMATTER
TONATION WEAPON SYSTEM

◄ Cardassians were shown to use a handful of other ships, including a freighter, a small scout ship and an upgraded version of the *Galor* class, which had a built-up section running along its back and was known as the *Keldon* class. This rejected design for the Cardassian missile in the *VOYAGER* episode, *Dreadnought,* owed a debt to the design of the *Galor* class.

DESIGNING THE
HIDEKI CLASS

The *Hideki* was a new Cardassian ship class that first appeared in *DEEP SPACE NINE*'s second season, designed by Jim Martin.

The *Hideki*-class Cardassian scout ship or shuttle made its debut in the second season of *STAR TREK: DEEP SPACE NINE*, adding to the roster of Cardassian ships that had been seen in the series.

SMALL DEBUT

The *Hideki* class made its debut towards the end of season two, in the episode 'Profit and Loss.' For this episode, the script simply described it as 'a small Cardassian ship.'

It would not be until the end of the following season that this type of Cardassian vessel would be referred to by its class, with a runabout computer identifying a: "Cardassian patrol ship, *Hidek* class." The ship's class was thought to be named by the writers in honor of theoretical physicist Hideki Yukawa (1907-81).

Some sources have credited *STAR TREK*'s senior production illustrator Rick Sternbach with the original design of the *Hideki* class. However, *DEEP SPACE NINE*'s then resident art department production illustrator Jim Martin produced the concept illustration that formed the basis of the studio miniature. This was an early design in Martin's time on the series following his promotion from the art department's PA.

▶ Jim Martin's original concept drawing for the Cardassian scout ship, which would later be dubbed the *Hideki* class.

▲ When the *Hideki* class appeared in 'A Call to Arms' VFX supervisor David Stipes used the original physical studio model.

▲ The CG version of the *Hideki* class made several appearances during the Dominion War and was scaled to be the same size as the Jem'Hadar fighter.

SET INSPIRATION

"I usually based my Cardassian designs on the interior design principles that (production designer) Herman Zimmerman and (set designer) Joe Hodges developed for the station," says Martin on how he approached a new ship for an established alien race. "There was a segmenting theme with angles that I liked to emulate. I would do that in props and ultimately in the *Hideki* ship design. Particularly, the wall plating in the station always made an impression on me. It was geometric and slightly 'reptilian plating' themed, which I thought had a sinister feel to it.

"Ultimately," continues Martin, "the Deep Space 9 station was my starting point for all Cardassian designs because it was always around me and inspired me as I walked the sets during work."

STUDIO MINIATURE

As was usual in the pre-digital VFX days of *DEEP SPACE NINE*, the studio miniature of the *Hideki* was likely to have been built by Tony Meininger's Brazil Fabrication & Design facility.

All the visual effects supervisors on *DEEP SPACE NINE* remembered the studio miniature of the *Hideki* class as an easy model to work with and, as always

with Meininger's model shop, beautifully painted. It was approximately two feet long and had top and bottom mounts for motion-control shooting.

Following its third appearance in 'A Call to Arms', the *Hideki*-class studio miniature was retired. Its remaining appearances in 'Sacrifice of Angels', 'Tacking into the Wind' and 'What You Leave Behind' was a new CG asset.

In 'Sacrifice of Angels,' the digital model was scaled to be roughly the same size as a Jem'Hadar attack ship. In 'Tacking into the Wind', the *Hideki* class seen onscreen was much smaller in scale to the attack ship.

(RETURN TO GRACE)

John Eaves 8/95

DESIGNING THE

GROUMALL

The Cardassian freighter *Groumall* was the first ship designed by concept illustrator John Eaves for *STAR TREK: DEEP SPACE NINE*.

▲ John Eaves' first concept sketch produced for the *Groumall*. At this stage, the design displayed the ship's origins more overtly in the design of the aft section, mirroring the Cardassian *Galor*-class warships.

John Eaves' professional relationship with *STAR TREK* dates back to *STAR TREK V: THE FINAL FRONTIER*, and as a contractor for various companies included work on *THE NEXT GENERATION*. He was hired to work as an illustrator on 1994'S *STAR TREK GENERATIONS* and shortly after found himself hired as concept illustrator in the art department for the fourth season of *STAR TREK: DEEP SPACE NINE*.

One of Eaves' earliest assignments for the show was to produce concept designs for the

Cardassian military freighter *Groumall*. The brief given to Eaves was to produce a cargo freighter that could conceal a large disruptor cannon within one of the ship's cargo holds.

The concept designer's starting point was to take some familiar elements from the Cardassians' major vessel, the *Galor*-class warship, which was originally designed by Rick Sternbach for *STAR TREK: THE NEXT GENERATION*. "I took the front end of a *Galor*-class Cardassian ship," says Eaves,

"and tried to fan off from that – using the front end, kind of sculpting it a little bit differently, and putting all these cargo bays in a row."

SECOND DRAWING

This first concept pass on the *Groumall* was put forward for consideration, and it was decided to modify the design from this initial drawing.

"The producers felt it was a little bit too Cardassian looking," recalls Eaves, "more a warship as opposed to a freighter. So between them and (executive producer Rick) Berman they wanted to see more of a 'storage unit' design. That's where the next drawing came in. It was just a series of boxes, all stacked on top of each other in series of sixes, with a big engine detail on the back and the familiar Cardassian fork on the front. They wanted it very 'freighterish,' so I put the bridge on the back, like it is on an oil tanker of today.

"That's where this design had come from," continues Eaves. "It's a bunch of huge, huge engines on the back which take it wherever you need to go. They wanted this more than the other one because it is very industrial looking."

At this point in *DEEP SPACE NINE*'s history, almost all new ships were made as physical models rather than computer-generated images. This normally involved producing fewer drawings. "Most of the time with models all you need is a three-quarter view, and a couple of three-quarter angles on different parts of the ship. I did plans just to show length and size."

REDRESSED, REVAMPED, REUSED

As was common across *STAR TREK* shows in the pre-CGI era, physical studio models were regularly reused in other episodes, often appearing as completely different ships, sometimes with alterations.

Following its first appearance in 'Return to Grace', the Cardassian freighter design next appeared in *DEEP SPACE NINE* just four episodes later in 'Rules of Engagement'. Here,

▼ The studio miniature model originally seen as the *Groumall* in 'Return to Grace' appeared a further four times in *STAR TREK* episodes, with small modifications made to both its hull colour scheme and warp-nacelle configuration.

▲ As a Cardassian freighter in *DEEP SPACE NINE*: 'Rules of Engagement'.

▲ Briefly seen in *VOYAGER*: 'Fair Trade', sporting a new colour scheme.

▲ Another Cardassian ship in *DEEP SPACE NINE*: 'For the Uniform'.

▲ Becoming Klingon freighters in *DEEP SPACE NINE*: 'Sons and Daughters'.

▶ A more refined concept sketch of the final design, moving the look towards the required freighter aesthetic. Eaves' notes established that the bridge was at the rear of the ship, and indicated where the disruptor cannon would be placed.

HIDDEN WEOPONNRY

BRIDGE

STAR TREK "DEEP SPACE NINE"

John Eaves 11/95 (RETURN TO GRACE)

Cardassian frieghter,

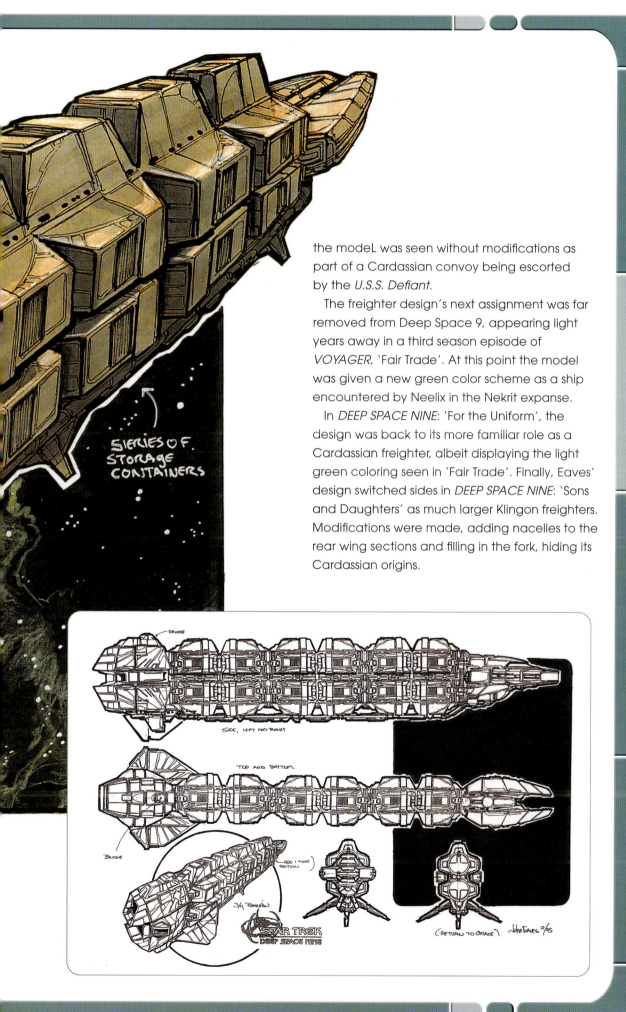

SERIES OF STORAGE CONTAINERS

the modeL was seen without modifications as part of a Cardassian convoy being escorted by the *U.S.S. Defiant*.

The freighter design's next assignment was far removed from Deep Space 9, appearing light years away in a third season episode of *VOYAGER*, 'Fair Trade'. At this point the model was given a new green color scheme as a ship encountered by Neelix in the Nekrit expanse.

In *DEEP SPACE NINE*: 'For the Uniform', the design was back to its more familiar role as a Cardassian freighter, albeit displaying the light green coloring seen in 'Fair Trade'. Finally, Eaves' design switched sides in *DEEP SPACE NINE*: 'Sons and Daughters' as much larger Klingon freighters. Modifications were made, adding nacelles to the rear wing sections and filling in the fork, hiding its Cardassian origins.

BRIDGE

SIDE, LEFT AND RIGHT

TOP AND BOTTOM

BRIDGE

ADD 1 MORE SECTION

3/4 REAR VIEW

STAR TREK DEEP SPACE NINE

(RETURN TO GRACE)

John Eaves 12/95

◄ Final plan views of the *Groumall*. Eaves supplied full plans to give the model makers guidance on length and overall size of the ship.

▲ John Eaves first thought was that the weapons platform would be a massive array like a space station that blocked the fleet's path.

DESIGNING THE ORBITAL
WEAPONS PLATFORM

The Cardassian Weapons platform started out as a huge space station, before eventually evolving into a design inspired by a salsa cup.

Sometimes the idea behind a design goes through major changes. Few things went through a more radical reinvention than the Cardassian orbital weapons platforms from the final episode of *DEEP SPACE NINE*'s sixth season. The Federation and its allies have decided to go on the offensive and take the battle to the Dominion. They identify the Chin'toka system as a weak point and assemble a fleet to attack it. But the Cardassians have a new weapon that they believe will repel the attack: a series of heavily-armed weapons platforms.

Concept artist John Eaves was under the impression that instead of lots of small weapons platforms, the Cardassians would have built a massive, space-station sized array "We started out kind of grand," Eaves says. "I came up with a massive flying archway with weaponry all over it. There would only have been one of them. We thought that to get where you were going you'd have to go through this thing. The Cardassians could move it, so they could put it into your path."

▼ In the episode, the weapons platforms draw their power from a small asteroid, which Eaves also produced drawings for.

Eaves remembers liking the fact that the design wasn't solid. "It was fun to have negative and positive space, so you could see through it." The open shape gave him places where he could place weapons. "The design isn't finished but I figured that all those little blocks sticking up from the surface would all be weapons." The surface detail on the station was designed to remind the audience of Deep Space 9.

The sketch was done in a morning, and presented in the afternoon, at which point the producers sent it back, asking for something different. "They wanted something more robotic, rather than a station," Eaves says. "The next idea we had was like a flying X. I'd done early work on *Terminator 2* and I always thought that the shape of the Hunter Killers was very menacing. I figured I could do something with that."

As the concept drawing shows, at this point the weapons platforms were still much larger than a *Galaxy*-class starship.

This next concept sketch was very rough and wasn't developed more

because Eaves' boss, production designer Herman Zimmerman, looked over his shoulder and asked him to take the design in a slightly different direction. "I did a revamp on it, and this time the drawing was much tighter.

▼ The second version of the platform had been scaled down, but was still large. The X shape meant it could focus firepower on a single point from different directions.

I was thinking about what would be threatening. When I was a kid one of the most intimidating things I saw were these longhorn steers that used to roam around outside our house. I decided to incorporate that so the front view is kind of like the skull of one of those steers. We presented the drawing in the meeting, but once again they told us they wanted something different, something that harkened back a little more to the familiar Cardassian designs.

"It was lunchtime so we went over to a Mexican restaurant next to the Paramount lot – Lucy Adobe," recalls Eaves. "We'd ordered chips and salsa. They brought out these little three-legged cups for the salsa. We had two of them, we flipped one upside down and put it on top of the other one. We looked at it and thought, 'OK, let's try that.' They loved it and it got approved!"

Eaves didn't plan for this version of the weapons platform to animate in any way. This is an idea that he credits the visual effects team with. "Dan Curry really liked this scene a lot. So he took it and really finished it off. He did an amazing job."

▼ Eaves' revised version of the X-shaped concept was loosely based on the skull of a longhorn steer.

John Eaves 4/98 DS9 #550
CARDASSIAN GUN PLATFORM.

◀ The final version of the weapons platform was inspired by the shape of the salsa bowls in a Mexican restaurant near Paramount studios. Eaves turned one upside down and stacked it on top of the other.

DEEP SPACE NINE #550 John Eaves 4/98

◀ Once Eaves had come up with the final design, he produced this quick drawing to show what the weapons platform would look like when it was in action.

▶ Jim Martin's approved concept drawings or the Jem'Hadar fighter established the look of the ship, but have some significant differences from the finished model.

DESIGNING THE JEM'HADAR
FIGHTER

DEEP SPACE NINE's showrunner, Ira Steven Behr, told everyone he wanted Sisko and his crew to find something really scary on the other side of the wormhole. The Dominion's Jem'Hadar soldiers and their ships would be tough, uncompromising and technologically superior to the Federation.

The Dominion would also be an ongoing threat, so everything about

them, including their ships, got a little more attention than usual. In the show's art department, production designer Herman Zimmerman had his concept artist Jim Martin explore several different designs for the Jem'Hadar fighter before they finally settled on a distinctive bug-like look. The brief they were given by the writing department was that the Jem'Hadar's technology should be noticeably different from anything we

had seen before, but not so strange as to be unrecognizable. Among Martin's rejected approaches to the new ship were some startlingly organic and angular drawings that show he was pushing the edges of what was possible before they settled on the final distinctively insect-like design.

Martin's drawings were handed on to VFX supervisor, the late Gary Hutzel, who had the task of turning them into a

JEM HADAR SHIP

MARTIN

physical model. As Hutzel recalled, when he started work, he had no idea that the ship would go on to appear in 30 different episodes. "Only Rick Berman and the writing staff knew the future use of a ship. The visual effects people were just told that there were potentially going to be a lot of clashes with these guys and that we might need multiple ships. I know there were a lot of illustrations. If I'd known how many

that would have been a giveaway that it was going to be an important ship."

At this point all the ships were still being built as physical models and on DEEP SPACE NINE most of the work was being done by Tony Meininger's Brazil Fabrications. Hutzel took Martin's drawings to Meininger and together they worked out how to build the ship. Hutzel explained that the process always involved changes, "You were

going from an illustration to a 3D object. We'd take a look at the drawings and go, 'Hmm, this element is not going to work.' So we spent an afternoon going over ideas about how we could make it shootable and talking about what the key design elements were.

"We had to decide which details were important. We had to plan a workable solution. Plus, in this case, because of the way that we were

▼▶ This angular design made it
clear that the Jem'Hadar ships were
aggressive and heavily armed.

▲ One of Jim Martin's more alien designs for the
Jem'Hadar fighter, which was considered too strange.

building it, we couldn't get those hard
angles. Tony was vacuforming his ships
and that had an influence on what you
could do. And, anyway, when you
looked at those shapes in relief they
weren't that attractive. So a lot of the
sharp edges and the raised triangular
wings on the back were traded out for
a more rounded look."

Hutzel and Meininger weren't only
looking for ways to make the ship easy
to build. Part of their job was to expand
on the ideas in the drawings, which
didn't even show the underside.

PUSHING THE BUG

"The next consideration for us was, 'How
far are we going to go towards making
this thing look like a beetle?' And the
answer," Hutzel laughed, "was 'Quite
far!' We really went for the bug,
including illuminating the underbelly
with those stripes, which was never part
of the illustrated design. That was
something that Tony and I added to
evoke that bug-like quality."

Once they had finished, Meininger

drew up a complete set of full-sized
orthographic views showing the ship
from every angle that would be used by
his model shop. As was normal on STAR
TREK, this final stage was left entirely to
the VFX team, with Berman, Behr and
the art department trusting them to turn
the approved drawings into a model.

Until now, everything showing the
design of the ship had been in black
and white. Seen in person, Meininger's
finished model is a startlingly strong color
– a distinctive combination of blues and
purples that was unlike anything seen
on STAR TREK before. Hutzel
remembered that the art department
requested a purple ship. "It was
specifically asked that it be purple and

we added the fuschia lighting scheme." If the ship appears rather less colorful on screen, it is because of the technical limitations of NTSC video. "Standard def color was very treacherous – it could end up a very undesirable color. We avoided that by desaturating it by about 50 percent."

UPPING THE ANTE

As Behr told *Cinefantastique* at the time, turning the Jem'Hadar fighter into such a badass ship had some unintended, but very welcome, consequences, "We said to ourselves, 'What have we just done? We came up with this unbelievably powerful enemy and we just have these crappy runabouts... We have to get a ship.'" When *DEEP SPACE NINE* returned for its third season, Sisko would have a ship of his own that was fit to fight the Jem'Hadar – the *U.S.S. Defiant* – and *STAR TREK* was ready to go to war.

◀ These drawings were created after Gary Hutzel and Tony Meininger had made their alterations to Martin's original concept and show a more rounded design, and exactly where the nacelles would glow.

◀ One of the original studio models produced by Meininger's model shop. The unusually vibrant paint scheme was toned down on screen.

Jem Hadar Attack Vessel
John Eaves 11/96

DESIGNING THE BATTLECRUISER

When a more threatening Jem'Hadar ship was required on *DEEP SPACE NINE*, production illustrator John Eaves turned to military inspiration.

As the main story arc of *STAR TREK: DEEP SPACE NINE* built towards all-out war between the Federation and the Dominion, it became clear that the Jem'Hadar had to operate more threatening ships to emphasize the grave threat they posed.

Production illustrator Jim Martin had designed the small Jem'Hadar fighter ships that had featured earlier in the series, but as he had left the show, the task of coming up with a new look for the

larger Jem'Hadar battlecruiser fell to his successor, John Eaves.

This was only the second ship Eaves designed for a *STAR TREK*, series, although he had been involved with work for the franchise since the late 1980s, when he was employed as a studio modelmaker on *STAR TREK V: THE FINAL FRONTIER* (1989).

Although mindful of the design language Jim Martin had established with the Jem'Hadar fighter, Eaves wanted to

steer away from copying its unique look for the new, larger ship.

MILITARY JET

Instead, he turned to old aircraft images for inspiration and based the design of the battlecruiser on the Douglas A-4 Skyhawk military jet. In particular, the cruciform style of the tail and the low-mounted delta-wings on the jet influenced the look of the elevated structures that emerged from the top

▲ The illustrations above show two of the early designs that John Eaves came up with for the Jem'Hadar battlecruiser. Both featured very angular styling and a forked nose section, elements that would make it into the final design.

rear section of the battlecruiser. Eaves envisaged the larger of these elevated structures as being the warp engines, while he thought of the smaller structures in between as being the impulse engines and piloting thrusters.

The curved-blade shaped wing tip pods that hung down below the main body were not the warp nacelles, as might be assumed. According to Eaves, these were the storage tanks for the fuel the ship's propulsion system required.

Eaves produced a three-quarter view of his design for the new Jem'Hadar ship, as he felt it was the fastest way to get across an overview of its appearance, and it was quickly approved by the series' producers. Eaves then drew up more elaborate and detailed plan views that were used by special effects house VisionArt to create a CG version. Modelmaker Don Pennington simultaneously built a physical studio model as the digital asset was created.

Due to budget constraints, the studio model of the ship was built from fiberglass rather than more expensive lightweight composites. As the model ended up quite large, measuring 48 x 48 inches, it weighed a considerable amount and took four people to lift and turn it for camera shots. While everyone thought it was a great-looking model, and it was easy to light and film, its hefty weight meant that it became affectionately known as the 'Lead Hadar'.

John Eaves '96 Jem Hadar Attack Vessel

▲ This version had a more traditional aircraft look with wings that swept back. A variation of this four-wing design did make it into the final look of the ship.

The studio model of the battlecruiser proved to be the second-to-last physical model that was built for STAR TREK and it debuted in the episode 'In Purgatory's Shadow', appearing for the final time in 'Sacrifice of Angels' as stock footage. It was sold at auction in 2006 for $7,200.

CGI APPEARANCE
The digital CG version of the Jem'Hadar battlecruiser, meanwhile, was also used in the season five episode 'In Purgatory's Shadow,' where several were shown inside a nebula chasing down a runabout piloted by Worf and Garak.

This marked the first of several appearances of the Jem'Hadar battlecruiser that have confused fans of the show, as its 'wings' appeared to be attached to the hull at a steeper angle, making it look like a different ship. The two designs – physical and digital – were intended to be the same ship, however, and the differences were down to a misinterpretation of Eaves' original design sketches.

Later, another CG version of the ship was built by effects house Foundation Imaging, where they had the studio model on hand for reference. As a result, this digital version matched the studio model and was first used in 'Sacrifice of Angels' and every subsequent episode the hefty battlecruiser appeared in.

The design of the battlecruiser proved to be ideal as it blended sleek styling with aggression and intimidation, making it the perfect ship for the Jem'Hadar and a worthy adversary for Starfleet.

Jem'Hadar Battle Cruiser "IN PURGATORY'S SHADOW" 1:12 11/96 John Eaves

◀ These plan views of the final design of the battlecruiser were drawn up by John Eaves. They were then used to build both a physical studio miniature and a CG model of the ship.

◀ The Jem'Hadar battlecruiser appeared in 13 episodes of *STAR TREK: DEEP SPACE NINE,* its first appearance being 'In Purgatory's Shadow' and its last in 'What You Leave Behind.'

New Revised Vessels

Dominion's New Attack Ship.

Defiant/Valiant size comparison

Dominion Battle Ship

THE VALIANT #546

JOHN EAVES 3/98

▲ John Eaves was the ideal person to come up with the design of the huge Jem'Hadar "attack ship," as he called it, because he had earlier devised the look for the Jem'Hadar battleship. This illustration shows the scale of the two ships side-by-side, and the main architectural differences between them.

DESIGNING THE JEM'HADAR
BATTLESHIP

Illustrator John Eaves was called upon to design a huge Jem'Hadar ship that had to be much more detailed than any previously built model.

The early script for 'Valiant' described a scene in which the U.S.S. Valiant flew close enough to a Jem'Hadar ship to "scrape the paint off," before attacking its support braces. There was just no way the existing Jem'Hadar battlecruiser model would

have stood up to such close scrutiny, as it just did not have that level of fine detail. Illustrator John Eaves was therefore asked to come up with a design for a new Jem'Hadar ship that was preferably larger and could definitely withstand closer examination.

Eaves had earlier designed the Jem'Hadar battlecruiser, although the intention had been for it to belong to another alien species altogether.

"I know it was for another species," says Eaves, "but when (visual effects producer) Dan Curry saw the sketch, he

said, 'I think we should make it one of the Jem'Hadar's ships.' He always had a thing for blades and knives. Of course, he was the one who designed the Klingon bat'leth, and anything that had a blade look to it would grab his interest right away. That's how the battlecruiser came into being and I thought, 'Let's carry this Jem'Hadar architecture through to the larger battleship.'

INITIAL IDEA

"At first, I came up with having the little beetle-shaped Jem'Hadar fighters docked on the sides of the battleship. I thought that was a pretty cool idea and they could detach and fly off to support the battleship. But it wound up being too complicated to make

a model of it. Jim Martin had designed the Jem'Hadar fighter to be like a bug, and sometimes a spider will carry its babies on its back, so we were following that idea for the battleship, but it ended up being scrapped.

"So I went for an exaggerated version of the battlecruiser. That was a good starting point, but the battleship departed from that a bit in that it was bulkier and had a flat-plane wing rather than a drop-wing design. It also had to have negative space areas where the *Valiant* could fly through these gaps in the architecture. I remember we also included a bridge-like detail which the *Valiant* flew under, so you got a real sense of the battleship's huge scale."

As Eaves based the battleship's style on his earlier look for the battlecruiser, it did not take him long to nail down its final appearance. "I didn't have to do many sketches," says Eaves. "I think all I was asked was to shorten the nose, and from there they built the CG miniature at Digital Muse.

"The whole style of the ship was a mix of World War II battleships from the U.S. Navy and British ships with aircraft carriers. That was the basis of the design and then I tied it in to the blade-like architecture of the earlier battlecruiser. It had that extra detail the producers needed and Digital Muse added their interpretation to the sketches I sent them. They came up with this incredible and imposing ship for the bad guys."

▼ Some of John Eaves' early concept art as a staffer on *STAR TREK: DEEP SPACE NINE*. This Karemma ship featured in 'Starship Down'. It would be built as both a physical model and a digital CGI construct.

STAR TREK
DEEP SPACE NINE

KAREMMA CARGOSHIP (SNSII) — John Eaves 9/95 VERSION II

DESIGNING THE
KAREMMA SHIP

Designed by John Eaves, the Karemma starship was created at the dawn of *STAR TREK*'s move into computer-generated imagery.

Having worked as a model maker in the motion picture industry throughout the 1980s, John Eaves worked on *STAR TREK V: THE FINAL FRONTIER* (1989) and later *STAR TREK: GENERATIONS* (1994). In 1994, Eaves was invited to join *STAR TREK: DEEP SPACE NINE* as a full-time production illustrator from the fourth season onwards. This began an unbroken run in the *STAR TREK* art department for the remainder of *DEEP SPACE NINE* and all four seasons of *ENTERPRISE*.

Among some of Eaves' earliest work on *DEEP SPACE NINE* was concept art for the Karemma starship as seen in 'Starship Down'. The episode was one of the first episodes of *STAR TREK* to make extensive use of computer-generated imagery,

with elements such as the *U.S.S. Defiant* and the atmosphere of the gas giant being created digitally.

A physical studio model of the Karemma ship was used for close up shots, while a CGI model was created for more distant sequences.

As a CGI construct, the Karemma ship was easily redressed to appear in other episodes of *STAR TREK* as different ships.

▼ John Eaves' plan views of the Karemma ship.

REDRESSES OF THE KAREMMA

▲ As a Bajoran impulse ship in *DEEP SPACE NINE*: 'Shadows and Symbols'.

▲ Reappearing in *VOYAGER*: 'Drive' as an Antarian vessel.

▲ A modfied version of the CGI model appeared in VOYAGER: 'Natural Law'.

▲ A final appearance of the CGI model in *ENTERPRISE*: 'The Breach'.

DESIGNING THE

BREEN WARSHIP

As *STAR TREK: DEEP SPACE NINE*'s last major villains, the Breen were given a ship that was radically different to anything that had gone before.

The Breen attack ship was one of John Eaves' last designing jobs on *STAR TREK: DEEP SPACE NINE*. He remembered that, as the series was coming to an end, the producers wanted something a little unusual. "It was for the show 'Penumbra.' (Executive producer) Ira (Steven Behr) wanted a new ship," says Eaves. "This was going to be the final ship design for *DEEP SPACE NINE*, so they said, 'Have fun with it and do what you want.'

"I started out with a 'T' shape; I wanted to take a letter out of the alphabet, and I thought the 'T' would make a fun ship. I put all the engines and the heavy stuff at the back, and put a real long nose on it. The first sketch I turned in – at the first meeting – they said they liked that direction very much, so I did a whole series of detailed drawings on it."

Even though Eaves had been given more freedom than usual, his first design had a lot in common with familiar *STAR TREK* ships, and while he was adding details to his initial sketch, the producers decided that they wanted something more radical. He explained that when he came to the next meeting, they told him to go back to the beginning.

BREAKING THE MOLD

"They said, 'Oh, that's what we figured you would do, but we want to go with something different. Come up

◄ The first design was of a fairly conventional T-shaped vessel, with engines to the aft and an aggressive fork at the front.

◄ On Eaves' next pass, he kept the 'T' shape, but made the ship much less symmetrical.

costumes. The producers liked his new design direction, and asked him to produce a drawing of a three-quarter view. Eaves says that at this stage they only had one comment. "They didn't like the wings breaking the exterior of the engines, so they had me take those off," recalls Eaves. "After I had done that, I did the three-quarter view and they started liking it more, but then they started seeing things they didn't like. They weren't sure what they wanted, so they had me do some other passes."

INDEPENDENT MODULE?
The part of the ship that caused the producers the most concern was the bridge module. Eaves said, "They thought it looked too much like a ship on its own – like it could break off and do its own stuff. They wanted me to change the shape of it so it became more of a module as opposed to a bridge. They wanted to go very asymmetrical; they liked that idea.

with a completely different shape that doesn't follow the *STAR TREK* lines – the normal position of the engines and all that stuff.'

DESIGN DEPARTURE
"So I went with another shape, but it still had that 'T' shape to it. I always kept to that 'T,' no matter what. Upside down this one still had the 'T' shape to it, even though it was broken up. I gave it two heavy engines, kind of a batwing

through the center of it, and I thought it might be fun to modulate things and suspend pieces as we went. So, in the second drawing it has a bridge module, which is up front and suspended on these wings; I was trying to give it a real distinctive look."

Eaves felt particularly free to experiment with the shape of the ship because so little had been established about the Breen; the only thing we had seen in previous episodes was their

▼ Eaves produced a three-quarter view of his second design, with various annotations showing the important areas.

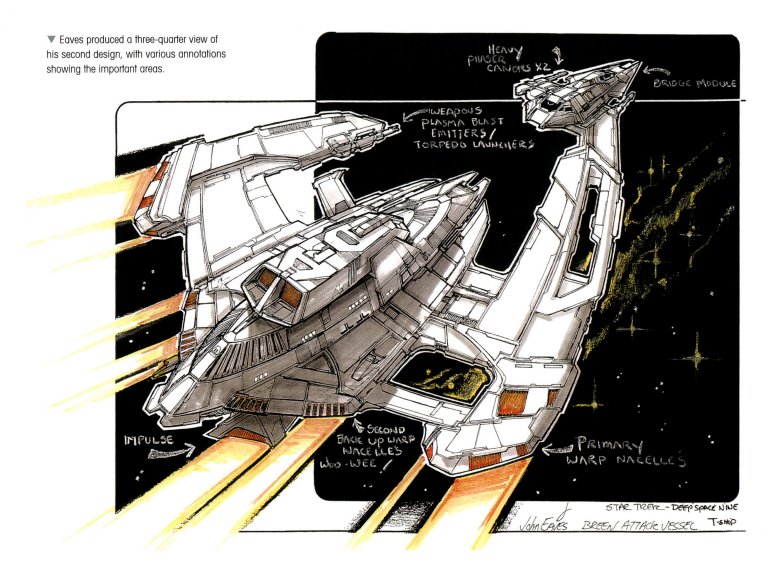

HEAVY PHASER CANONS X2

BRIDGE MODULE

WEAPONS PLASMA BLAST EMITTERS / TORPEDO LAUNCHERS

IMPULSE

SECOND BACK UP WARP NACELLE'S WOO-WEE!

PRIMARY WARP NACELLES

STAR TREK - DEEP SPACE NINE
John Eaves BREEN ATTACK VESSEL T-SHIP

I met with visual effects producer Dan Curry and all the visual effects guys, and we started working it out together. Dan had a lot of ideas that would be fun to work with, and, as the meetings went on, it continued to funnel into different shapes.

NEW DIRECTION

"I started doing details of that module," continues Eaves. "By the time these drawings were done, they had thought a little bit more about it and they wanted to go in a whole new direction, so that ended this whole design phase."

The bridge module was dropped, and Eaves developed a pinched, 'dartlike' ship that looked very aggressive. "The next design was probably one of my favorites," says Eaves. "I initially drew it to fly in one specific direction, but then I got to thinking – because of a misunderstanding that came up on STAR TREK: INSURRECTION – I would draw it so it could fly either way and it wouldn't matter.

"They really liked that, and I got to continue with the 'T' shape. I did another drawing showing it flying the other way, and they really liked the aggressiveness of it. But as they looked at it, scale-wise, it looked more like a fighter than a big ship. So they asked for a whole new look, putting the previous designs to one side. Visual effects supervisor Gary Hutzel saw this design and said, 'Keep that, and we'll put it somewhere in the background if we get the chance.'"

SEPARATE LEVELS

Eaves explains that his next drawing didn't quite satisfy everybody, but it did hold the key to the design of the final ship. "I went with another design, which had all these open-faced wings and forks," says Eaves. "I tried to give a lot of different planes, and tried to keep it as alien as I could. They really liked this idea, but there was something about it they still didn't like. They weren't really sure what, though. They said, 'Take it and mess around with it a little bit more.' That's where the final drawing came

FORWARD

HEAVY
WEAPONRY

IMPULSE
ENGINES

BRIDGE

PRIMARY WARP
DRIVE

SHIP CONCEPT
#4A

John Eaves 1/99 BREEN ATTACK VESSEL #567 PENUMBRA.

► Eaves particularly liked the third design, but the producers rejected it because it looked too much like a small fighter.

► This design, which had lots of different planes, started to establish a direction that met with the approval of the producers.

John Eaves 1/99 SHIP CONCEPT #5A
BREEN ATTACK VESSEL #567 PENUMBRA

▲ After a little experimentation, Eaves locked the final design. His colleague Doug Drexler then took on the next step, which was to build the CG model.

John Eaves 2-2-99 BREEN SHIP

from, and this was the one they really liked. They said, 'It's really nice, it has all these different planes; we can layer it, and it looks like nothing we've had before – it will really stand out in a battle scene.' They had me do a plan view, which was the top view."

CG MODEL

Eaves outlines that once he had finished his work, one of his colleagues in the art department took over. "Doug Drexler did all the modeling for (CG house) Digital Muse to do their final passes on," said Eaves. "Gary Hutzel had him do it because it was something Doug always wanted to do, and he had the

program. Gary wanted to give him a chance to see what his creativity could do. Doug spent the whole time refining areas, putting details through. He stretched it a little bit, made it a little longer, which really added some aggressiveness to it. He came up with a bizarre gun on the front, which worked out great. Doug really made a great model and I loved the color he chose for it. In the final ship from the top view, you could still make out the stylized 'T' shape that had been the basis for the whole design."

Looking back, Eaves says he was pleased with the way his last ship for *DEEP SPACE NINE* turned out. "It was

very nice to break the standard *STAR TREK* mold; it was a very fun ship to do," he smiles. "We went through an awful lot of changes, but I was really happy with the final ship. It started out with a symmetrical layout and then turned into an asymmetrical style that really captured a far more alien feel.

TEAM EFFORT

"I think it worked out great that we all got to work together on it; the drawing wound up being a rough guide for Doug to use. All the shapes are the same, but when it went to the extremely fine detail, he did a real good job and had some great ideas."

DESIGNING THE
KLINGON BATTLECRUISER

The Klingon battlecruiser is one of *STAR TREK*'s most enduring designs, but the producers didn't always think they needed it.

During the filming of *STAR TREK* in the 1960s, two things were particularly rare: recurring aliens and spaceships. The Klingons returned occasionally following a first appearance in 'Errand of Mercy', , but they were never part of a grand plan. New spaceships were prohibitively expensive and mostly represented by dots of light on screen. As production on season three commenced in 1968, with budgets that were tighter than ever, the production team had no plans for a Klingon battlecruiser. "We had no need for a Klingon ship," production designer Matt

Jefferies explained, "nor did we have a budget to do one, or time to design it or build it."

However, in the first season, model company AMT had made a successful kit of the *Enterprise.* "That model sold over a million the first year," Jefferies said. "So AMT wanted a follow up."

As it had with the *Galileo* shuttlecraft, AMT offered to build a model for the show as long as they could have the rights to market a kit of it. *STAR TREK* didn't have a detailed model that could be

used for the Klingons, so the producers agreed, but, as Jefferies explained, it was always a side project. "I designed it at home because there was neither the time or the money to do it at the studio. Gene pretty much left me on my own. Primarily it was done for AMT but it was something that would fit the show and we did use it."

Jefferies wanted the design to reflect the Klingons' nature, which he thought of as "cold" and "vicious."

▲ The Klingon battlecruiser returned alongside the *Enterprise* in *STAR TREK: THE MOTION PICTURE,* when it received some signficant upgrades.

▶ Matt Jefferies (left) designed the Klingon battlecruiser so that AMT would have another ship to build a model of. He wanted it to have similar components to the *Enterprise* (which he had also designed) but with new shapes and a different layout.

SEARCH FOR A KLINGON

"The Klingons were supposed to be pretty wicked people," he said, "so I wanted their ship to have something of a killer potential that would look wicked. Naturally, I thought it had to look as far out as we thought the *Enterprise* did."

With this in mind, Jefferies sat at his drawing table and tried to draft out something, but, just as with the *Enterprise*, he didn't find it to be an easy process. "I was after a shape, but I didn't really know what it would be. God knows how many sketches there were. I saved some of them but I'm sure I must have trash-canned maybe a hundred balled up pieces of paper. It was like when you make a mistake in arithmetic – you keep going back over the same piece of paper and you keep making the same dumb mistake. Somewhere you've got to throw it away and start from scratch. I don't know how many drawings were done on it. Sometimes, if you felt you had something, which could be kind of rare, you turn it around as many ways as possible and all of a sudden something may pop up that makes more sense."

Jefferies wanted the ship to look as if it used roughly the same technology as the *Enterprise*, so he gave it nacelles (or engine pods as he always called them), a neck with a head on it, and a body. Initially, he returned to an idea that he had rejected when he had designed the *Enterprise*, and made the head spherical but, unlike the *Enterprise*, most of his drawings show the head and the body on the same plane. Eventually, he elongated the head to make it egg-shaped, and settled on a shape for the body.

"KLINGON"

MASTERS AND MOLDS

"I was feeding on a stingray, or the manta, for part of the shape," he said. Even though it is not dangerous, a lot of people think the manta ray has a very vicious look to it. Yet to see it swimming, like a shark, it is a very graceful thing. I was trying to get all of that and still have something that looked far out. Once I was happy with the basic sketch, I took that and hardened it; established what size it would be in relation to the *Enterprise* and did a scale drawing. That's what we handed to AMT. It was a full engineering drawing."

AMT then made two tooling masters of Jefferies' design. Jefferies was pleased to see how faithfully they followed his drawings, and made regular trips to supervise AMT's work.

"I made three trips out there at their expense. The master models were quite large, probably close to 18 inches across, I guess. Then they made the molds using what they call a pentagraph, where a stylus traced its way over the master model, and the other end of it carved out the

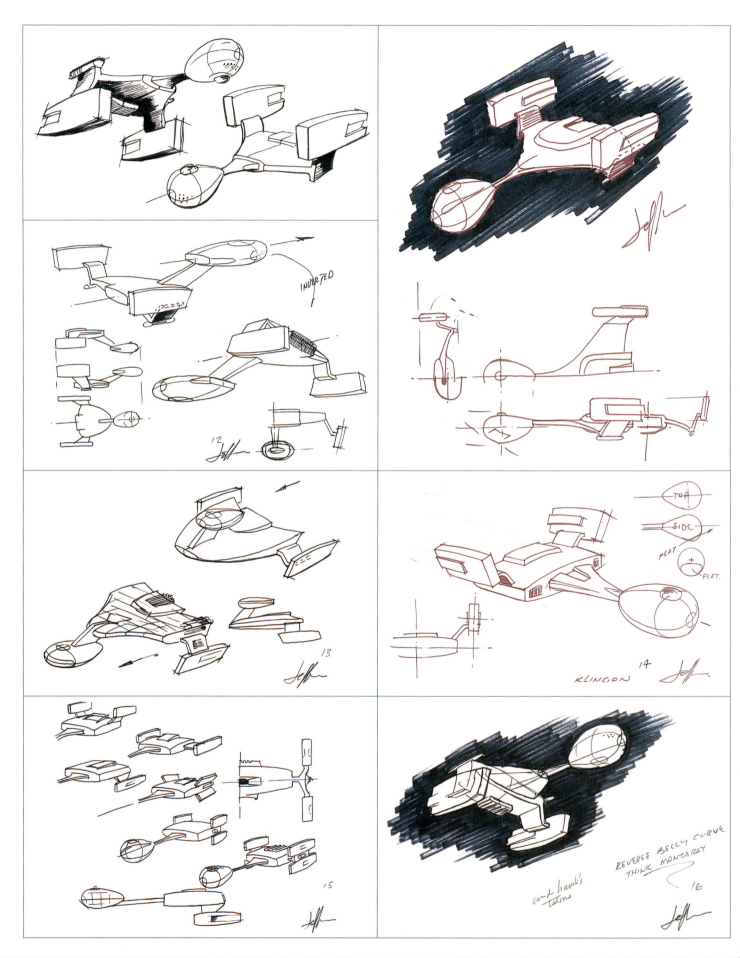

INVERTED

'12

'13

KLINGON 14

TOP

SIDE

FLAT

FLAT.

'15

REVERSE BELLY CURVE
THINK MONTANA?

and hawk's
talons

16

same shape in tooling steel, which became the mold they built the kit from.

READY FOR ACTION

"I was there, it was about 2 o'clock in the morning, when they ran the first two or three through the machine. There was flashing in some places. They said, 'We'll take out a fraction here, and a fraction here.' Then they'd run two or three more. If I remember correctly, it was about 10 o'clock when the first one came out they said was perfect. They ran maybe another half a dozen, and checked those out. Then the machine was put in operation and after that one came out every 20 seconds."

The model went on sale in August, a month or so before the Klingon ship made its debut on screen.

Around the same time, series writer D.C. Fontana wrote a piece for 'STAR TREK Insider' that revealed the thinking about the layout of the ship. She placed the bridge in the "top front of the bird-like head," which she said also contained "quarters, labs and armament control." She revealed that weapons were located on the underside of the head, where they were combined with a sensor, and along the leading edge of the wings, which contained "storage, fuel, power source, environmental control units, etc."

Meanwhile, Jefferies had taken one of the tooling masters with him for use in filming. He painted it himself. "The coloration came directly from a shark. It's a grayish-green on top and a lighter gray underneath." The Klingon symbol,

◄▲ Jefferies based the shape of the new ship on a manta ray, which he thought looked threatening. He produced dozens of drawings trying to find the right approach, before he settled on a design he liked.

KLINGON BATTLE CRUISER ALTERNATE ARRANGMENT OF POWER UNITS

JEFFERIES

NO FINAL 11·20·67

24

▶ Even when the design was all-but final, Jefferies was still considering alternatives. This version shows the warp nacelles mounted on top of the engineering hull.

again designed by Jefferies, made its first ever appearance on the top of one of the wings. "The logo had to be something small and compact that you could recognize quickly," Jefferies remembered.

The model was shot by the Howard Anderson Company, who handled most of STAR TREK's effects. The first script to feature the ship was 'Elaan of Troyius,' which was the second episode of the

season to be filmed, but thirteenth to be broadcast. However, the Klingon battlecruiser – also known as the D7 – made its first appearance in 'The Enterprise Incident.' The producers were keen to make as much use of their new model as possible. This story involved the Enterprise facing off against Romulan ships. In order to make use of their new model they decided that the Klingons and Romulans had entered into an alliance and the

▶ This was the final sketch for the battlecruiser. Jefferies also produced a series of detailed engineering drawings that AMT could use to make the final model kit.

KLINGON BATTLE CRUISER

JEFFERIES 67

FINAL

▲ Concept artist Andrew Probert was working at Robert Abel and Associates and had a major influence on the look of the re-designed Klingon battlecruiser.

Romulans were now using Klingon ships. The footage was used again in 'Day of the Dove.'

Several years after *STAR TREK* was cancelled, the original master model was donated to the Smithsonian. The battle cruiser made a handful of appearances in *STAR TREK: THE ANIMATED SERIES,* where Kor's ship was named the *Klothos*.

THE KLINGONS RETURN

When work began on the aborted TV series *STAR TREK PHASE II* in 1977, the producers decided that the Klingons would return. They were slated to appear in a two-part story, 'Kitumba,' which would have seen Kirk and his crew venture deep into Klingon space in an attempt to prevent a war, and in the pilot, when *V'Ger* would wipe out three Klingon ships on its way to Earth.

During preproduction, work began on the VFX models and the production team retrieved the original model from the Smithsonian so that visual effects company Magicam could make a new miniature. Magicam took measurements and created a new mold, but they were still working on the model when Paramount decided to upgrade the television series and make a movie instead.

At this point, Robert Abel and Associates were brought in to supervise the effects. Abel's art director, Richard Taylor, asked Magicam to build a

▶ The script for *STAR TREK: THE MOTION PICTURE* opened with three Klingon battle cruisers encountering *V'Ger* and apparently being destroyed. The various VFX teams produced different storyboards for the sequence, including these.

◀ The team at Abel always wanted to increase the level of detail on the model. Probert created these images by drawing on top of photographs of the new model that Magicam built.

new version of the model because it needed more detail if it was going to be used on the big screen. In an interview with American Cinematographer, Magicam's Jim Dow said that at one point Magicam proposed building an eight-foot-long version of the model, before the Abel team asked for it to be scaled back to four feet.

CINEMATIC UPGRADES

"We did re-build the Klingon ships," Taylor remembers. "One of the things we did with all of the models was to give their surfaces details interesting designs. A smooth object has no scale, so it's important in model work to find ways of creating scale. Sometimes it's very subtle, but it's one of the most important elements in model photography. We re-designed all the surface textures, the photon torpedo tube and many other details. I tried to put a kind of bird-feather design on the surface. "

Taylor also asked Magicam to change the shape of the module on top of the head. It had been shaped like a bean sitting on the surface, and now became a 'tower' with sloped sides.

Early on in the building process, Taylor brought one of his concept artists, Andrew Probert, with him to Magicam to check over their progress, but as Probert remembers he had some concerns about the model that was on offer. "The Klingon battle cruiser was about half finished at that point. I took a look at the model and I whispered to Richard, 'The neck is crooked on that ship.' It was actually tilted down. Being a STAR TREK fan, you recognize shapes, and I could tell they'd built it wrong. Richard was compelled to point that out. They were instantly insulted, but after studying the plans, it was discovered that they had used the wrong line on the drawings for the centerline."

Another concept artist, Greg Wilzbach, produced drawings for revised warp nacelles. Even at this point Taylor wanted to add more detail to the model. Probert remembers taking photographs of Magicam's existing model and sketching new details over them.

"There weren't a lot of changes," he recalls. "Most of them were cosmetic. I was very into gun

TRAILING EDGE TO BE RECESSED

INTERCHANGEABLE
SHIP'S "NAME" PLATE
PLATE WOULD CONFORM TO
GENERAL SCRIBED PATTERN.

▲ One of the big breakthroughs was the feather pattern that was applied to the surface. At first this was only done with paint, but later it became physically raised detail.

placements, because before that it was anybody's guess as to where these phasers were firing from. So I put gun emplacements around the Klingon ship and created a hangar bay for its shuttles, and just did a lot of small detailing. One of the modelers working on the skin detailing came up with the idea of creating a feather-like plating on the ship, and it was wonderful. In order to see it better we enhanced it with thicker echoings of that pattern, so that's how that developed."

Magicam did use castings from their *PHASE II* molds to create some simple shells of the Klingon battle cruiser, which they planned to blow up when the beam from *V'Ger* hit them.

By this stage Magicam had done a lot more work on the model than they had ever anticipated and were concerned about the budget. Abel took over the models and set up their own model shop, where they continued the detailing work on the battlecruiser. Mark Stetson, who worked for both Magicam and Abel picks up the story: "Once the model was delivered to Robert Abel & Associates, Magicam deemed their work contract complete. Abel set up a modelshop at Seward Street, under supervisor Dick Singleton, to continue with design development and detailing. Ricard Taylor's designer Andy Probert would visit the modelshop at Seward and work hands-on with the models, doing detail and paint work alongside the model crew. The model crew included Dennis Schultz, Zuzana Swansea, Joe Garlington, Chris Elliot, and later in January 1979, me."

By the time the Klingon model had to be filmed,

▲ Probert also produced sketches showing a variety of details. The Klingon typeface makes its debut in the film. It was never used on the wings as Probert suggested but did appear in graphics on the bridge.

▶ This photograph shows the battlecruiser attached to a motion control mount that would control its movement when it was filmed for bluescreen work.

Abel and Associates had left the production and Doug Trumbull had taken over effects work. Due to the tight schedule, he brought in John Dykstra, who was given responsibility for the Klingon sequence that opened the movie. Dykstra wanted a close shot on the bridge of the Klingon ship before flying over the top. This meant that an area of the model that was only a few inches across had to fill a massive cinema screen. In order to make this work the model was upgraded again, with Pat McLung taking the opportunity to rewire the lighting and upgrade the paint scheme.

▶ The finished model had to be incredibly detailed in order to stand up to the close-up shots that John Dykstra wanted to film. The original dark green paint scheme wasn't immediately obvious on screen.

KLINGON Interiors

The scenes on the Klingon bridge were among the last to be filmed for *STAR TREK: THE MOTION PICTURE*. *TMP*'s production designer, Harold Michelson, had moved on to another project by the time they were filmed, so the task of designing the bridge fell to Douglas Trumbull. "There was something that would be intrinsically malevolent about this interior," he remembers. "I came up with the idea that it would be heavily rigged for battle and would have these huge shock absorbers that would kind of look like spider legs."

Trumbull asked Andrew Probert to take this brief and come up with some concepts for the bridge. "He wanted to get the feeling of an enemy's greasy, dark, crowded interior," Probert says, "like the inside of a submarine, and he wanted to have these huge shock absorbers to keep the bridge area dampened from any hits the ship might take. That was basically all he said, so I came up with several sketches."
The bridge set was always designed with visual effects in mind. Trumbull planned an impressive shot where the beam that

'digitized' the Klingon ship engulfed the ship from the back. "Trumbull wanted to see the energy wave from *V'Ger* go through the bridge," Probert explains. The solution was to build the bridge in six different sections that could be rolled out of place and replaced with a bluescreen as the bridge disappeared. In the end the shot in which the bridge disappeared was barely a second long, but filming the sequence was a real technical challenge and shows the level of the filmmakers' ambition.

KLINGON BRIDGE ORIENTATION

KLINGON BRIDGE — INTERIOR

► These images show the
finished model that was used
for filming STAR TREK: THE
MOTION PICTURE from a variety
of angles. The script for the STAR
TREK PHASE II pilot identified
the ship as Koro-class, but the
novelization of TMP renamed it
the K'T'inga-class.

◄ The plan was to show that the Klingon ships had been recorded inside *V'Ger*. Robert McCall produced several pieces of art, including this one, that showed this sequence, but the shots were eventually dropped from the film.

As Dykstra recalls, they wanted to show that *V'Ger* was actually digitizing everything it encountered, so when the beam hits them, the Klingon ships weren't actually destroyed. "Rather than blowing them up in a great huge explosion we came up with the idea that this thing somehow transformed the mass of the ship into an enormous amount of energy." The plan was that when Spock entered *V'Ger* he would see the Klingon ships recorded inside it. Robert McCall proposed several concept paintings showing this.

For a long time, no-one was sure exactly how the movie was going to end. As Probert remembers, Trumbull suggested that when *V'Ger* dissipated, the Klingon ships could return.

"Trumbull's idea was that *V'Ger* dumps all of these memory crystals into orbit, and a couple of them collide and develop back into the Klingon battlecruiser. His thought was that, in a kind of a knee-jerk reaction, the Klingon commander sees the *Enterprise,* their enemy, and fires on it."

McCall produced a painting showing the *Enterprise* and the Klingon ships together and Probert worked on some storyboards for the proposed sequence. He added the idea that during the battle the *Enterprise* would separate its saucer for the first time, after the Klingon ship had disabled her engines.

While the Klingon battlecruiser seen in the original series was given the designation *D7*, Gene Roddenberry's novel of *STAR TREK: THE MOTION PICTURE* named the class as *K't'inga*. Although never referred to as such on screen, it has become accepted as the name for this era's Klingon battlecruisers.

The model of the Klingon battlecruiser was available to the *STAR TREK: THE NEXT GENERATION* VFX team along with the other models that were used in the features, but it barely made any appearances on the small screen. Greg Jein did make new models of the battlecruiser using the molds that Magicam had made for *PHASE II,* one of which featured prominently in DEEP SPACE NINE's 'Trials and Tribble-ations.' Foundation Imaging created a CG version of the battle cruiser for *DEEP SPACE NINE* for use in many of the large battle sequences.

The original *K't'inga* model was brought out of storage for *STAR TREK VI,* where it served as Chancellor Gorkon's flagship *Kronos One.* Industrial Light & Magic' John Goodson and Mark Moore repainted it, giving it a more elaborate paint scheme that they reasoned was appropriate for the Klingon chancellor. While the model has only been used sparingly, the design has become a classic that has inspired the design of many other Klingon ships. As recently as 2019, a new version of the *D7* battlecruiser made its debut on *STAR TREK: DISCOVERY.* This brought the battlecruiser full circle, establishing its introduction in the *STAR TREK* universe a decade or so before its appearances in the original series.

DESIGNING THE
VOR'CHA CLASS

When the Klingons first appeared on *STAR TREK: THE NEXT GENERATION* they were still using the two ships that were designed for the movies – Nilo Rodis' *Bird-of-Prey* and the *K't'inga* class, an updated version of Matt Jefferies' original Klingon *D7* battle cruiser.

The producers and the art department occasionally discussed giving the Klingons a new, 24th-century ship, but this did not come to pass until the season four episode 'Reunion.'

The task of designing this new ship fell to *TNG*'s senior illustrator Rick Sternbach. Sternbach had been designing ships since *TNG*'s first season, but most of them had been single-use vessels that were never seen again. It was obvious this Klingon cruiser would be used regularly, and he was excited by the idea of designing a major ship.

"The *Vor'cha* class was my first main ship that would be seen more than one time," says Sternbach. "With ships of the week I didn't use the same brain cells to produce the shapes, though they all need to turn out visually interesting and, technologically at least, somewhat plausible. They are fun, but the Klingon attack cruiser was truly a design challenge that required a synthesis of much of what we knew about Klingon spacecraft.

KLINGON FLAGSHIP

"As I recall from the production meetings on 'Reunion,' the description called for a new Klingon 'attack cruiser,'" continues Sternbach, which was to be similar to the original battlecruiser, and would serve as the flagship for Chancellor K'mpec. This implied that the attack cruiser was likely to be the largest ship in the Imperial Klingon Forces, apart from cargo carriers or troop transports, as well as the most advanced."

Although this was a new ship, Sternbach knew it had to be obvious that it was a Klingon vessel. He also wanted to suggest that it was the 'modern' version of the original battlecruiser, establishing a link between *TNG* and the original *STAR TREK*.

"We wanted a visually recognizable ship with a known lineage," explains Sternbach. "In most cases I needed to include something familiar, even if it's only the hull paint scheme or a few details in similar locations as on previous ships. If we go really far out then it might take a few pages of dialogue to explain what we've done. In this case the intent was to echo Matt Jefferies' original (*D7*) design right from the beginning; we wanted to give some sense of continuity in the evolution of Klingon warp vessels.

FAMILIAR SHAPES

"The basic shapes were the head, long neck, wide aft body, and canted nacelles. I worked up a few variations, but tried to stay within the original proportions. It isn't hard to see that this is a Klingon design, given our art department's penchant for keeping the shapes and color schemes of different cultures distinct."

Despite the obvious continuity between the two designs, Sternbach wanted to make sure that the new vessel looked more advanced than its predecessor. It also had to look at home next to the contemporary Klingon ships.

"Nilo Rodis' *Bird-of-Prey* design figured into the mix, with the large slotted radiator blocks," says Sternbach. "The upgrades of the battlecruiser from *STAR TREK: THE MOTION PICTURE* and *STAR TREK VI: THE UNDISCOVERED COUNTRY* also contributed, with features such as the body panel surface break-up, impulse nozzles, photon torpedo launchers, and the like."

There were also practical reasons for updating the design ethic. In the 1960s,

▼ Rick Sternbach began the design process by sketching out a few rough possibilities, basing the basic shape on Matt Jefferies' original *D7* battlecruiser.

▲ ▼ These drawings show how Sternbach was experimenting with the different elements he wanted to include and how he began to add more detail.

▼ This three-quarter view was Sternbach's last drawing before he prepared the blueprints. Some elements, such as the disruptor platform at the back, had already been created in sketch form, but this was the stage at which he worked out most of the surface detailing.

STAR TREK's models tended to be smooth. This was partially because Matt Jefferies reasoned that starship designers wouldn't put elements that needed servicing on the outside of their vessels, but also because it made it easier to build the filming models.

"The surface detailing is there because smooth miniatures have been notoriously difficult to light convincingly," adds Sternbach. "The addition of raised detail helps a lot. Surface textures and coloring also add levels of detail that are more interesting to look at and help to sell the idea of large scale."

The surface detail was directly linked to the earlier movie-era Klingon ships, but Sternbach also made a significant departure from the established Klingon design, which he built in to suggest the improved relations between the Klingons and the Federation.

STARFLEET INFLUENCE

"The color scheme was purposely not purely Klingon," explained Sternbach. "I wanted to subtly suggest that because of the uneasy alliance between the Klingon Empire and the Federation, there were some transfers of

technology that had eased the attack cruiser toward a more Starfleet look."

Sternbach often worked out a lot of information about the ships he designed, and the *Vor'cha* was no exception. Several of the components, such as the impulse engines and transporter emitters, were familiar, but he said that the *Vor'cha* had a few capabilities that were never revealed on screen.

"Like most *STAR TREK* ships, the attack cruiser had all the right parts, and those are all fairly recognizable," he explains. "The exact functions of

Greebled Area

Lit Red

Polished brass tubing

Lit Nose Caps

Trek [4].
Klingon Attack Cruiser
ALT. HEAD I

EXISTING BODY

Repeat plate detail

Scale EXISTING
NAV deflector,
Attach to bottom

sternbach
/. 91

Trek [4].
Klingon Attack Cruiser
ALT. HEAD II

Reminicent of original
Series

phaser
trapazoids

sternbach
/.91

◄ Sternbach designed
the forward weapons
module of the *Vor'cha*
class to be ejectable in
cases of emergency,
but this capability was
never seen on screen.
These illustrations show
design alternatives of
the weapons module.

some of the hardware chunks and
piping were left to the imagination,
I suppose, and could be determined
later if the need arose. The repeating
plate details were meant to convey a
feeling of heavy armor plate, and while
the operational specs of armor in the
24th century were vastly different from
those for today's Centurion tank, the
feeling was the same.

EJECTABLE BRIDGE
"The forward elevated section was
a flying bridge; presumably it was
ejectable in a crisis, like the bridges of
the *Enterprise*-D and the *U.S.S. Voyager.*
The aft raised wedge was designed as
a large disruptor platform, though I
think it could also have served as a
small scout vessel."

One of the most obvious departures
from the original *D7* battlecruiser was
the forked unit at the front of the vessel.

Sternbach added this because he
wanted to give the Klingons a new
and dangerous weapon.

"The forked front end was derived
from some terrific energy weapons
prevalent in Japanese anime
productions like 'Macross,'" says
Sternbach. "The Klingons already had
disruptors and torpedoes, and I felt that
this new main vessel should have at
least one special bit of armament.

"The side units were designed to
guide, like a rifle barrel, an enormous
volume of energetic plasma emitted
from the central cannon. The entire
head end was, of course, an ejectable
weapons pod that could conceivably
be swapped out with other pods for
specific missions. I liked to tell folks that if
the pod had to be ejected in battle, the
disruptor crew became instant heroes
of the Klingon Empire and went straight
to Sto-Vo-Kor."

◄ The final stage was
to prepare blueprints for
the modelmaker. This
drawing of a *Vor'cha*-
class warp nacelle
indicated the kind of
materials that should be
used and which areas
had to light up. The
model was built by
Greg Jein at his workshop
in Santa Monica.

DAUGHTERCRAFT SCOUT SHIP

PHASER EMITTERS

IMBEDDED W
(These are ca

SENSOR STRIP

CARGO LOADING DOOR

IMPULSE INTAKES

OUTBOARD DISRUPTERS (2)

PHASER EMITTERS

COM ANTENNA (2)
(Lower Head and antennae are supposed
to look like snake head and fangs)

MAIN DISRUPTER CANNON

DESIGNING THE
IKS NEGH'VAR

The design for what would become
known as the *Negh'Var* warship
began in March 1994. Senior
illustrator Rick Sternbach was asked
to come up with a look for a "future
Klingon ship" that was due to appear in
STAR TREK: THE NEXT GENERATION's final
episode 'All Good Things…' At this point,
it was thought the ship would only ever

appear in this one episode, so the cost
of designing and building a brand new
Klingon ship from scratch could not be
justified. Instead, Sternbach based his
design on the existing *Vor'cha*-class
model, adding features that could be
easily applied to the existing model.

"An alternative timeline upgrade of
the *Vor'cha* was called for in the story,"

says Sternbach, "and so I added some
proposed modifications to the original
attack cruiser sketch, suggesting new
hardware bits that could be attached
to the existing filming miniature. These
modifications had the same basic
styling as used on the original, but
hopefully looking different enough to
say it was a new design. Word came

LES

DGE

D TORPEDO LAUNCHER

◀▲ To help keep the cost of building a studio model to a minimum, illustrator Rick Sternbach added new hardware to his earlier *Vorcha*-class ship design. The illustration above shows one of Sternbach's first passes at the design, but the producers wanted it to look even more different, so he added further elements, including a revised front end with a 'cobra' head and a detachable scout ship as can be seen in the main illustration on the left.

▲ The *Negh'Var* model was relatively small because it was built from the same molds that had been used to create the *Vor'cha* model. When it was first designed and built, it was known within the *STAR TREK* production as the 'Voodieh' class. This was probably a corruption of the Klingon word 'voDleH,' which means 'emperor.'

through that the producers wanted a somewhat more radical take on the cruiser, so I followed up with another sketch. This featured some of the add-ons that I had previously suggested, but made them integral to the design, with some new proportions.

"The design was definitely still Klingon, but different enough to see it wasn't a *Vor'cha* with some bits stuck on," adds Sternbach. "The wing platforms were reversed, bending forward to give a hint of a bird-like shape, the engines were clipped slightly and embedded within the wings, while 'canards' were

blended into the nose area. I also gave it a new main bridge, an ominous 'snake head' at the bow, 'fang' antennae, and a new disruptor cannon. Like most ship designs I got to contribute on, this was an absolute ton of fun."

ANNOTATED FEATURES
As can be seen on the annotations that Sternbach added to his illustrations, he intended for the spike at the front of the ship to be the main disruptor cannon, although the ship was never seen firing from this position. He also intended the fang-like protuberances to be

communication antennae, while the built-up section on top of the main body was supposed to be a detachable emergency craft.

"I suppose the 'daughtercraft' was an extension of the thing I did on the *Vor'cha* with its main disruptor cannon section," says Sternbach. "That is to say, I designed it to be detachable in a fight if the ship was disabled. I was influenced by the movie *The Beast of War*, which (*STAR TREK* production designer and art director) Richard James worked on, where one of the Russian tank guys said, 'Out of commission, become a pillbox.

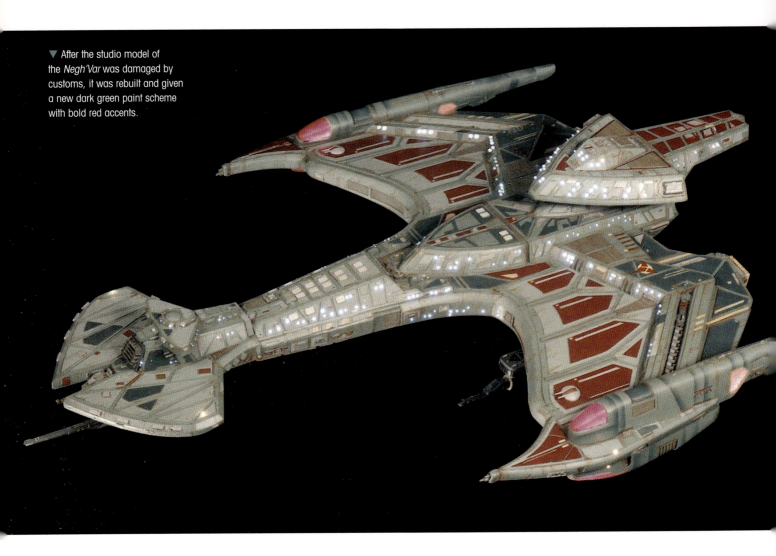

▼ After the studio model of the *Negh'Var* was damaged by customs, it was rebuilt and given a new dark green paint scheme with bold red accents.

Out of ammo, become a bunker. Out of time, become heroes.' I figured that would work for the Klingons. It wasn't that the little ship was there to run away, but more to give them options to fight."

Once Sternbach's design had been approved, his illustrations were sent over to Greg Jein's workshop in Santa Monica. Jein had built the original *Vor'cha* attack cruiser, so it made sense that he should also build this "future Klingon ship" studio model. He modified the molds of the original *Vor'cha* model to create it, and this meant that the center part of the ship, which included the neck, was identical. It also meant that the model was relatively small, measuring approximately 33 inches x 24 inches. The model maintained the same color scheme as the *Vor'cha* class, being placed at a midpoint between

the dark green of the *Bird-of-Prey* and the light gray of the *U.S.S. Enterprise* NCC-1701-D. Separate portions of the ship were also built, including the port wingtip section, cast from the molds of the master model, as in the episode these parts were blown off the ship when the future *Enterprise*-D attacked it.

SENT ON TOUR
After the filming of 'All Good Things…', it was assumed that the "future Klingon ship" would never be seen on screen again, and it was loaned out as part a touring STAR TREK exhibition.

Meanwhile, John Eaves, who had been hired as STAR TREK's resident illustrator between the third and fourth seasons of DEEP SPACE NINE, was asked to come up with some designs for a new, larger Klingon ship. While Eaves did

produce some new concepts, it was decided that the cost of building a new studio model was beyond their budget.

Instead, the producers realized they could save money by using the existing "future Klingon ship" as the *IKS Negh'Var* and it was recalled from the exhibition tour. Unfortunately, during transport, the model was severely damaged as effects supervisor, the later Gary Hutzel explained. "Apparently, when the Negh'Var model got to customs, they thought there might be drugs inside, so they broke it open. It was in pieces. That was a nasty surprise."

While the model was being repaired, modifications were made and this was the reason why some of the details were different from its appearance in 'All Good Things…' to its next appearance in 'The Way of the Warrior.'

The two 'fang' fins on the bottom of the bow and the nacelle spikes were removed, the long front spike was shortened, but extra 'weapon' pods were added under the 'wings.' The overall color scheme was changed too, and it was repainted in the same dark green seen on the Klingon *Bird-of-Preys*.

The *Negh'Var* model was next used in the mirror universe episode 'Shattered Mirror,' where it portrayed Regent Worf's flagship vessel. Here, it appeared in an almost identical configuration, although the spike in the nose of the ship was now removed completely.

FINAL APPEARANCES

The *Negh'Var* was next seen in the episode 'By Inferno's Light,' but this just featured stock footage of it from 'The Way of the Warrior.'

The *Negh'Var* studio model's final outing came in another mirror universe episode, 'The Emperor's New Cloak,' where it was seen in almost the same configuration, although now the short spike had now returned to the front of the ship.

The *Negh'Var* then became a CG model for its appearance in *STAR TREK: VOYAGER*'s finale 'Endgame,' making it the last physical studio model to be translated into a CG model. It was built at visual effect house Foundation Imaging by Trevor Pierce, and incorporated design elements from all its previous appearances. Thus, the CG version featured a long spike at the front and the two 'fangs' attached to the bottom of the bow as the studio model had in 'All Good Things…' It also featured the weapon pods below the 'wings' as it had in its appearances on *DEEP SPACE NINE*, although the tips of these pods were now colored red.

The original studio model of the *Negh'Var* was sold at the Christies' '40 Years of *STAR TREK*: The Collection' auction in 2006 for $26,400.

◀ When the *Negh'Var* model was first built at Greg Jein's workshop, it was painted the same color as the earlier *Vor'cha*-class model. It also featured 'fang'-like fins on the bottom of the bow and disruptors on the tips of the 'wings.'

◀ Initially, the *Negh'Var* model had a long spike in the nose of the ship. Sternbach intended for this to be the ship's main disruptor cannon, but it was never seen firing from here. This spike was later shortened when the model was rebuilt.

◀ As well as a new paint scheme, the later *Negh'Var* model featured weapon pods beneath the 'wings,' and extra windows. Meanwhile, the long spike in the nose was shortened and the disruptors were removed from the tips of the 'wings.'

▼ The Klingon *Raptor* was the first new Klingon ship that appeared on screen in *ENTERPRISE* and was deliberately conceived as a more primitive version of the original series battlecruiser.

DESIGNING THE
KLINGON RAPTOR

When John Eaves was asked to design a new Klingon ship for the *ENTERPRISE* episode 'Sleeping Dogs,' he knew two things: first, it would be the first new Klingon ship to appear on screen for ten years and second, it would be a ship from the 22nd century. This meant that it needed to look far more primitive than any previous Klingon ship, and it still had to be immediately identifiable as part of a Klingon fleet.

The *Raptor* may have been the first Klingon ship to actually make it to the screen in one piece in *ENTERPRISE*, but it wasn't the first one Eaves had designed.

The Klingons had already appeared in two previous episodes and in both cases new ships had been designed. In the pilot, 'Broken Bow,' the ship was only seen crashed on the ground. Eaves had also designed a battlecruiser that was a more primitive version of Matt Jefferies' classic design, which was used in 'Unexpected'. Suitably armed, Eaves had some ideas about the approach he wanted to take.

DIFFERENT ERAS

Eaves started his design process by studying previous ships such as the *Bird-of-Prey* and the *D7* battlecruiser,.

Working backwards chronologically gave him a sense of how to modify the architecture of those ships without interfering with the basic shape.

"For me there are basically three periods of design," explains Eaves. "There's exposed piping and stuff on the early, early, Archer stuff. The Kirk stuff has smooth panels and then because of the giant scale of the ships, there's the heavy panel break up of the Picard era. The original *D7* had more body than wings. So when it comes to the older stuff, I try to show that wings were kind of state of the art at that time. They don't need to be aerodynamic in any

► When John Eaves started work on the *Raptor* he thought it was going to be a much smaller ship, like these designs for a Klingon shuttle. As the script progressed, the ship got larger until it finally ended up with a crew of approximately 12.

way but the fact is I try to do wings for anything I could, like the shuttle for the *Enterprise* NX-01. Then, I try to make sure that the ship looks more like it is made up of different pieces that are attached to one another as a opposed to a uniform shape."

Where the Klingon ships were concerned, Eaves took inspiration from the look and design of the Golden Gate Bridge, where exposed cabling held everything together. With that in mind, he produced a series of quick sketches of the *Raptor*, which Herman Zimmerman, the show's production designer, submitted to the producers.

CHANGING SHAPES AND SIZES

"I really tried to come up with a shape that they would approve by sending things over that had the right architecture but in different configurations," recalls Eaves. "In this case there was quite a gamut of shapes. Originally it was supposed to be a shuttle, then it got bigger as it went

on. My thumbnails go from little two-man sized things to four-guy ships, up to the one they chose, which I figure is like a 12-guy ship."

Once the producers had decided on a sketch that best represented their idea of the ship, designer Doug Drexler was then tasked with refining the design, as well as constructing a first stage CG

▼ John Eaves took inspiration from the *D7* battlecruiser and *bird-of-prey* in developing an earlier iteration of ship that was immediately identifiable as Klingon.

model in industry standard 3D-modeling software Lightwave.

"The sketch given to Doug showed the *Raptor* in a fair amount of detail and clearly established it as a 22nd-century design but only showing one view," says Eaves. "Usually if it had been a sketch going to be sent up to Eden FX, I'd give them side, top, all that stuff. For Doug I didn't because he only sat a few yards away and we could talk back and forth about it. I think it was great the way that Doug was able to interpret my drawing and add what he thought the past should look like. Even though the shape had been approved, the details – the shuttlebays and all the little neat things were pretty much in his hands."

Drexler continued to refine the design as he built the model, but he insists it was not his job to make any alterations to the shape, but to reinforce the overall impression that the producers wanted to give.

BROUGHT TO LIFE

"For me, the *Raptor* has a PT boat Civil War ironclad quality to it," says Drexler. "John's sketches suggested a trussed and cabled quality that I was sure to include in the model. Those distinctive touches helped to date it. The coloration is metallic but suggests the gray tones of Matt Jefferies' original battlecruiser. We were still a way off from the murky Japanese submarine

rusty-green of later years."

As soon as work on the model was completed, it was handed over to Rob Bonchune and Pierre Drolet at Foundation Imaging, where they used Drexler's model as the basis for a fully camera-ready version. This was built in pristine condition, and the damage was added for the final shots.

Eaves was delighted with Drexler's final model, which he says took his design to another level. "Even though we work in different mediums, we think a lot alike about the details, but what he was able to do with the computer is a whole world I can't really perceive. He turned those sketches into a far better design than I could have done."

▼ Doug Drexler's original 3D version of the *Raptor* was used to establish what the ship would look like in 3D before it was handed over to Foundation Imaging.

▲ Pierre Drolet used Drexler's model as the basis for his own more-detailed version. As you can see, the design evolved subtly as the model was rebuilt.

▶ The finished design for the Augments' ship was recognizably Klingon, but the design process started with some radically different ideas before being pulled back towards something more familiar.

DESIGNING THE
KLINGON ATTACK SHIP

In the last days of *STAR TREK: ENTERPRISE*, John Eaves was called on to design a mysterious new Klingon ship.

When the Klingon attack ship first appeared on screen, its origins as a Klingon ship were left unclear. With this in mind, concept artist John Eaves was asked to come up with something that *could* be Klingon, but wasn't too familiar.

"(Supervising VFX Producer) Peter Lauritson wanted something really, really different for this," Eaves remembers. "He didn't know if he wanted us to go retro or for a sleeker version, or exactly what he wanted, but he was very clear he didn't want

to have a *Bird-of-Prey*. He said do something completely different, make it angular, make it something that we've not seen before. That was the guidance behind the design."

By this point, there had been nearly 700 episodes of *STAR TREK*, so designing

▶ Eaves' earliest rough sketches for the attack ship show most of the elements that ended up in the finished design. You can see that he started to think about taking familiar elements of exisitng Klingon ships and compressing or extending them to create something new.

something completely new was a challenge. "We had drawn so many ships on this show that we were running out of shapes," laughs Eaves. "It was kind of like I had writer's block. I didn't know what other shapes to do!"

Initially Eaves produced three rough drawings. One showed a fairly familiar Klingon design with an extended neck and wings. This was instantly rejected for being too familiar. Another drawing showed a much smaller, more compact design that was reminiscent of Goroth's ship in 'Bounty' from

ENTERPRISE season two. This idea had some traction but, as Eaves recalls, it also fell by the wayside. "Peter liked that shape so we went with that for a while. I ended up using that as the head of the ship, instead of it being a separate ship." The third drawing was

more of a departure. It showed a design like the head, which Eaves had extended and blended into the shape of the engine pod from the Klingon battlecruiser. This concept got the nod and Eaves was asked to work it up into a more finished design.

STRANGE INSPIRATION

His solution to his 'artist's block' was to find somewhere new and different to look for inspiration. "We went down to the mill and looked at tools to see if any of those shapes could turn into ships," says Eaves. "They had this long level that bowed in the middle – you'd hang it on a string and it

would give you a floating level – and that was where the shape for this ship came from."

Using this as inspiration, Eaves produced three alternative designs that he could take back to the producers. "We came up with these very unusual shapes. They've all got really strange long, long dimensions. A couple of them you'd never know were Klingon. Some of those drawings were wingless. It was almost like a stealth dart as opposed to a winged vehicle."

Although the wings on these designs were truncated, Eaves didn't remove them completely. And, in this case, he

returned to a much more conventional source of inspiration. "I was looking at aircraft carrier aircraft when they have the wings folded up. I thought it would be cool if that was the basis of the design. The wings would have been stationary – they don't extend – but it looked like they folded out. We ended up with this very Egyptian shape. The only thing that would distinguish them as Klingon was the kind of break up I had on the panels."

In Eaves' mind the ships he was designing were all relatively small. "There was a point where they said no windows and no lights, so you really don't have a sense of scale. Normally

that was your guide. As I was drawing I figured it was not necessarily super small; it had a crew of maybe 15 or 20 people."

Ultimately, the producers felt that the wingless designs were too great a departure and didn't look Klingon enough. The version they chose was most like Eaves' original pencil sketch with short, but very recognizable, wings. When it came to the color, they also decided to stick with a familiar Klingon green. "I asked what color they wanted," recalls Eaves. "'Do you want a grey or a dark metal or something?' They said, 'Let's go with the green but don't put

markings on it.' I guess the idea was that without markings you wouldn't know it was Klingon."

TECHNICAL HITCH

This last stage presented Eaves with a problem he had not previously encountered. "This was the very first thing I did in Photoshop. I was just learning it and I hated it. I drew it with a mouse on a laptop. It was agony! Mike Okuda was sitting there and he said, 'Let me help you.' I wasn't getting it. 'I don't want to learn this. I like markers!' In the end I printed it and did pencil on top of it!"

▲ Some of the rejected concepts for the attack ship had an almost Egyptian look, with short wings. Eaves describes them as being like a stealth dart.

▶ John Eaves made these quick sketches of Goroth's transport ship based on a design that he had originally drawn up for a Klingon shuttlecraft.

3/4 REAR VIEW

HATCH OPENS

FRONT

TOP

SIDE

DESIGNING THE KLINGON

DESIGNING THE KLINGON
TRANSPORT SHIP

With time and money being tight, illustrator John Eaves turned to a previous concept when designing a new Klingon transport ship.

Before *STAR TREK: ENTERPRISE* began filming, concept artist John Eaves was incredibly busy working up illustrations for the designs of everything from *Enterprise* NX-01 interiors and shuttlepods, to alien ships.

"It was definitely like a movie workload," says Eaves. "There were an enormous number of sets in the pilot

– they went to a trade center, an ice planet, and then there were all of the bad guy sets and their ships."

Among these concepts, Eaves was asked to design a Klingon shuttlepod, a single occupant craft which, according to the script, was to streak through the sky before crashing into a field on Earth in the pilot episode 'Broken Bow.' Eaves

came up with a couple of designs, one of which featured a craft with clearly separate nacelle structures. However, the producers preferred an alternative concept that was much more compact. In the end, neither of these designs was featured in the episode.

"I don't recall seeing anything on screen, except maybe a blur of the ship

▼ This more elaborate concept saw the ship grow significantly in size, and its horseshoe shape was more clearly defined. Eaves also drew a concept of the escape pod in which Captain Archer fled from the ship.

BELLY VIEW OF SHIP WITH POD LAUNCHING IN FOREGROUND

HIGH VIEW OF TRANSPORT WITH ESCAPE POD FOR SCALE

▶ This was the colored-up version of the design that Eaves came up with for the single occupant Klingon shuttle that was to have featured in 'Broken Bow.' When it was not used in the pilot episode, Eaves based Goroth's ship on its basic architecture.

crashing,' adds Eaves. "The sequence was a bit more elaborate in the script, with the ship pile driving across the corn field in a very Superman-esque type of crash. All of this was eliminated due to time or costs, and a less complicated idea took to the screen instead."

MODIFIED DESIGN
This meant that Eaves' concept for the Klingon shuttle was never featured on screen, but when another Klingon vessel – Goroth's transport – was

needed for season two's 'Bounty,' Eaves knew just where to turn to save time. "The script called for another Klingon ship of different architecture from the big wing designs," says Eaves. "It had to be a cheap build, so we

pitched a redress, revamp and rescale of the 'Broken Bow' shuttle because the CG model existed already. It was born from a new adaptation of its prior concept. It made for a fun redraw and it looked really nice on screen."

▼ The script called for a Klingon ship that could haul deuterium, but John Eaves figured that all Klingon ships were designed for combat, so he came up with a hybrid version that could also serve as a battlecruiser. It would later appear without the tanks.

DESIGNING THE

KLINGON D5

In *ENTERPRISE*'s second season, the script for 'Marauders' called for something never seen before: a Klingon tanker. By this point, John Eaves had already designed two Klingon ships for the new series. A 22nd-century version of Matt Jefferies' classic battlecruiser had been rejected at the last minute so hadn't appeared on screen, and the Klingon *Raptor* from 'Sleeping Dogs'. He rapidly decided that even though the script called for a tanker, the tanker should be instantly

recognizable as a Klingon ship and be ready for war. "I never wanted the Klingons to have a ship that didn't have battle capabilities," he remembers.

The shape he sketched out followed the basic lines of the Klingon ships he'd already designed and Nilo Rodis' classic *Bird-of-Prey*. "Loosely it was somewhere between the *Raptor* and the *Bird-of-Prey*," he recalls. "You definitely see a lot of the *Raptor* in it. The nose is very Raptorish, the engine pods are very Raptorish. The *Raptor* has a

more of an aggressive look and I put the wings down so it didn't have that attack mode look to it."

Eaves had come up with some rules for 22nd-century Klingon design, which he carried through here. Most obviously, he gave *ENTERPRISE*'s Klingon ships exposed cabling, which was inspired by Soviet-era harnessing systems. He also gave his Klingon designs an open space at the back of the nacelles. "On submarines they sometimes have that little coop that the water would be

▲ Eaves' sketch was handed on to Eden FX, who built the CG version. They stayed fairly close to the design, but when they built the model they felt the nose section was "too stubby," so they extended it.

▶ After Eden FX had built the CG version, Eaves produced a drawing that reflected the changes in the design. It wasn't needed for the production: it was part of the process of teaching himself to use Photoshop.

forced through," he explains. "This was the same idea: that everything is generated in the front half of the nacelle and then focused through that open section. I thought that gave the technology the look of an earlier era."

As Eaves reveals, the nacelles also featured a nod to Matt Jefferies' design that was meant to tie them in to ships from Kirk's era. "It has a double cylinder in the middle of the nacelle. You can see something similar on the Jefferies version of the ship."

The design has another Easter egg hidden in it. When the *Bird-of-Prey* had been designed for *STAR TREK III*, it was originally going to be a Romulan ship. After Leonard Nimoy decided that the Klingons should be the main villains the ship changed hands, but the design stayed the same. "I was talking to Mike Okuda," Eaves recalls "and we were goofing around, talking about the idea

that the Klingons had stolen it from the Romulans. I thought maybe this ship could also have a tie-in to the Romulans, so that double neck piece is taken from the *Valdore.* I was trying to hint that maybe they stole that technology, borrowed it or bought it."

Most importantly, Eaves had to make the design capable of hauling deuterium. To accommodate the tanks the script called for, he extended the neck and put a bar underneath that ran the length of the ship. "It has a beveled boxed-off section," he explains. "That would be a permanent part of the ship. Whatever you needed to carry would attach to it. If you needed cargo that would have a U-shape, that would wedge right up underneath. The tanks were individual pieces that only attached on the sides."

When it came to designing the tanks themselves, Eaves was inspired by a

very real 21st-century parallel. "I was changing the oil on my car," he laughs, "and I thought the little oil filter was really cool, so that was the inspiration for the shape of the tanks."

Eaves produced a single sketch, which he presented to the producers. He remembers that they embraced his suggestion that all Klingon ships would be ready to fight and were interested in his idea that the ship could carry a variety of different kinds of cargo.

"When I showed them the sketch, they were talking about how we could put different types of cargo on the bottom. For that particular episode it was a tanker, but they thought that it might have the potential to carry something else in a different episode, like shipping armaments or moving hazardous items. It was going to be a multi-functional ship, but in the end you only saw it as a tanker."

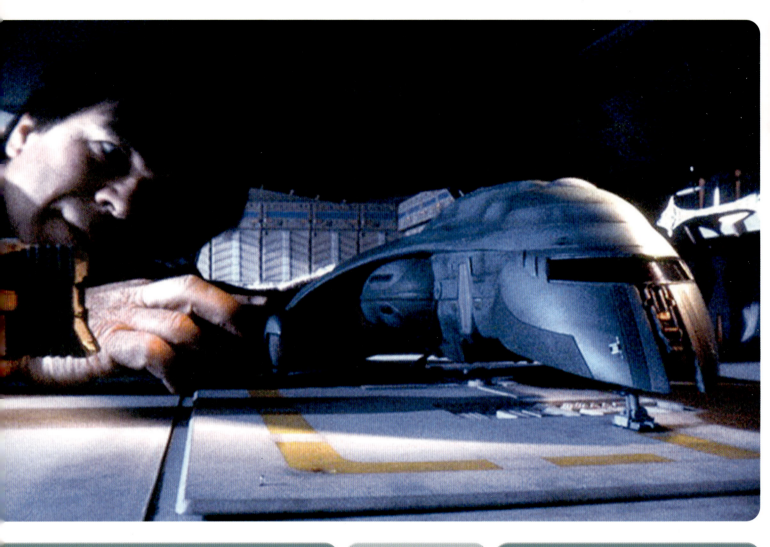

DESIGNING THE
ROMULAN SHUTTLE

The Romulan shuttle was designed by Doug Drexler, who used previous Romulan ships and his pet parrot to inspire its creation.

The Romulan shuttle was the first new design of Romulan ship seen since the Romulan scout ship of eight years earlier in *THE NEXT GENERATION* third season episode 'The Enemy.' The shuttle was also one of the last designs to be made into a physical studio model, as by this time CG had almost completely superseded shooting with studio miniatures.

The Romulan shuttle came into being because VFX supervisor Gary Hutzel needed a shot establishing that Senator Vreenak had arrived at Deep Space 9 in season six's 'In the Pale Moonlight.' It would be a brief shot, so rather than have a new design fully drawn up, which would cost time and money, Hutzel turned to scenic artist Doug Drexler.

▲ The model of the Romulan shuttle was filmed at visual effects house Image G. Stationary shots were taken of the model inside a maquette of Deep Space 9's shuttlebay that was also specially constructed just for this episode.

▼ Doug Drexler drew up a design for the Romulan shuttle in double-quick time.

Although officially credited as a scenic artist on *DEEP SPACE NINE*, almost from the beginning Drexler also doubled as a production illustrator, turning his hand to designing props and ships when the need arose.

HAPPY TO HELP

As the various departments got on so well, Drexler was only too happy to help out his friend Hutzel. In fact, they had worked up a familiar routine for times like these. "Just like when our production designer, Herman Zimmerman, would come to

me with an assignment, he used a phrase that became an art department catchphrase: 'Oh, by the way...' With Gary, it was 'Would a guy like you be willing to do something like this for a guy like me?'" laughs Drexler. "So, Gary trundled into the art department and asked if someone like me would... well, you can guess the rest. I was just that kind of guy. I had a couple of days to get it together."

Drexler started by making a few quick 'back-of-an-envelope' type sketches of the Romulan shuttle at home. He based the look on

▲ The Romulan shuttle was one of the very last fully fledged physical studio models ever built for *STAR TREK*. By this point, CG was commonly used, but in this case, VFX supervisor Gary Hutzel preferred a traditional model.

◀ This picture shows how the camera was set up to film the Romulan shuttle inside the framework that was built for the shuttlebay. No motion control photography was required, as stationary shots were all that was required of the model.

the aesthetic that senior illustrator Andrew Probert had established for the Romulans when he designed *D'deridex*-class Warbird for *THE NEXT GENERATION*'s first season. He also used the appearance of his own pet Amazon parrot for inspiration. This was despite the fact that Drexler had given the parrot a Vulcan name – B'kr, or Beaker.

The sketches were straightforward and fast, but Hutzel liked them. Drexler drew up some more detailed drawings of a very tight side and top view in Adobe Illustrator. These illustrations were then sent to Tony Meininger, who ran Brazil Fabrication & Design, the company that had built many of the studio models for *THE NEXT GENERATION* and *DEEP SPACE NINE*.

Just a few weeks later, Drexler was called down to Image G, the company that filmed the models, to see the finished result. "I was blown away by the work," recalls Drexler. "They kept my design one-hundred percent, while embellishing it with incredible sensitivity and grace. The Romulan shuttle turned into a fan favorite, even though it appeared just once, in the Deep Space 9 hangar bay. I was tickled when Andy Probert gave the shuttle his seal of approval by painting

it into the '*STAR TREK*: Ships of the Line' calendar, on the page he did of the Warbird in drydock. Although, Andy did try and trip me up, pointing out that the hatches on the spine of the Warbird were for lifeboats, and that scale-wise they didn't work for the shuttle. I told him they were for sensor probes. He liked that!"

◀ Doug Drexler with his Amazon parrot, B'kr, which provided some of the inspiration for the design of the Romulan shuttle. The back and tail of the parrot can be seen in the lines of the dorsal and aft sides of the shuttle, while the head of the ship was modeled on a combination of the *D'deridex*-class Warbird and a Spartan's helmet.

CREATING THE
ROMULAN SCIENCE VESSEL

The Romulan science vessel was an adaptation of a Romulan scout ship that had been designed by Rick Sternbach for an earlier episode.

When a Romulan science vessel was needed for the *STAR TREK: THE NEXT GENERATION* episode 'The Next Phase,' the producers decided it would be better to adapt an existing studio model rather than go to the expense of building an entirely new one.

Fortunately, they already had a suitable Romulan model that could be easily altered to fulfil their needs. This was the Romulan scout ship that had originally appeared in the episode 'The Defector,' and had not been seen since.

Senior illustrator Rick Sternbach had originally come up with the design for the Romulan scout ship, which was intended to be a fairly small ship, with a crew of no more than half a dozen. The final look of the ship had a distinctly birdlike shape, as he tried to echo the shapes that had been established for the Romulan Warbird. The head of the ship and the hull plating, in particular, were designed to be reminiscent of other Romulan ships, emphasizing their distinctive architectural style.

HEAD SWAP

Sternbach also intended for the head of the ship, which contained the bridge, to be ejectable, so it could be used as an escape pod in an emergency. This feature proved important when modifying it into a science vessel, as the head section looked like a distinctive module that could be removed. In fact, that was precisely what they

▲ The Romulan science vessel was created easily by changing the head section of the existing Romulan scout ship, and adding a semi-circular piece to the tail.

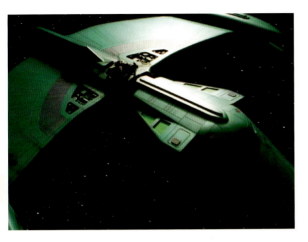

▲ The model started off as the Romulan scout ship, which had featured in the earlier season two episode 'The Defector.'

did at Greg Jein Inc., the model workshop where the alterations were made.

Once the original pointed head had been removed, the people at Greg Jein's workshop searched through their drawers of spare parts until they found a blunt diamond-shaped piece that looked like it had been made to fit. They also added a flat semi-circular piece to the tail of the vessel, but kept the main body and wings the same. They finally repainted the model a slightly lighter shade of green to complete the transformation from scout ship to science vessel.

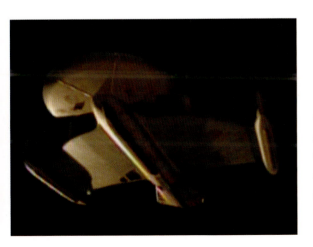

GREAT OPPORTUNITY

The same studio model was reused again to depict the *Nerada*, a Nasari starship, in the *STAR TREK: VOYAGER* third season episode 'Favorite Son.' This time, no modifications were made to the shape of

the vessel, but it was given a new bronze paint scheme at Brazil-Fabrication & Design, the workshop run by Tony Meininger. The only other change was that the flight direction was reversed, so that the semi-circular module was now the front of the ship.

The model was sold in this configuration at Christies '40 Years of *STAR TREK*: The Collection' auction for $6,600.

▲ After its outing as the Romulan science vessel, the studio model was repainted and used as a Nasari starship in *STAR TREK: VOYAGER.*

▲ These sketches show Rick Sternbach's design for the Romulan scout ship. He was not asked to modify the concept to transform it into the Romulan science vessel. Instead, Greg Jein's workshop was left to make suitable alterations to the studio model.

DESIGNING THE VULCAN
WARP SLED

For *STAR TREK: THE MOTION PICTURE*, Gene Roddenberry wanted
Spock to arrive in a shuttle that could catch up with the *U.S.S. Enterprise.*

As the *V'Ger* cloud approached Earth,
destroying everything in its path, Admiral
Kirk took command of the *U.S.S. Enterprise*
and set off to intercept it– but Kirk's ship was
missing a vital component: his first officer, Spock.
The upgraded *Enterprise* was barely fit for service,
so Kirk was relieved when a Vulcan shuttle dropped
out of warp and delivered Spock.

As the Vulcan shuttle's designer Andrew Probert
remembers, Gene Roddenberry had specific
requirements for the Vulcan shuttle, chiefly that it
shouldn't look like anything seen before in STAR
TREK. "The idea was that Spock needed to catch
up to the *Enterprise,* and this had to be done in a
shuttle. Gene explained that it needed very large
warp engines and to hard dock with the ship itself."

APPEALING SHAPES

Probert began by sketching out some possible approaches as he looked for a shape that appealed. His earliest drawings show that he was thinking about suspending a small ship between two massive nacelles. He theorized that since the *Enterprise* had just been fitted with state-of-the-art warp nacelles with a rectangular cross section, the shuttle would be older and have the same circular nacelles that were seen on the television series.

As he sketched, Probert encountered a problem: Roddenberry was clear that he wanted the shuttle to dock with the *Enterprise,* but the nacelles were so long that they were getting in the way. "I had the major headache of trying to place very large engines on a shuttle that had to hard dock with

▲ Probert's first thought was that the shuttle would have massive engines that would enable it to travel at high warp.

the *Enterprise*," he recalls. In order to address this, he swept the nacelles forward so he could put a docking ring on the back of the shuttle. At this point he flattened the nacelles, but something about this approach wasn't working for him. Then inspiration struck: the shuttle (or personnel pod) and the nacelles (or stardrive section), could actually be separate units. "Eventually," Probert explains, "I came up with the idea of a warp sled, which the actual shuttle would leave behind to do its docking." The nacelles now hung below the shuttle like a catamaran, with a platform on the top where the shuttle itself was mounted.

Once he had this idea, Probert wanted to make it clear that the new ship was Vulcan rather than standard Starfleet issue. At the time, there were no other Vulcan ships, so there were no established designs for him to draw on. "What I did," he explains, "was I went back to the

episode 'Amok Time' where Spock and Kirk fight, and I noticed that the Vulcan gongs had a very distinct coffin shape. I took that as a section for the engine pods."

UNIQUE LOOK
This approach gave the nacelles a unique look, implying that Vulcan technology was subtly different from the rest of Starfleet's. However, Probert didn't want his 'warp sled to look like too much of a departure. He deliberately echoed the detailing on the inside of the *Enterprise*'s nacelles, which he had also designed alongside art director Richard Taylor. As always, he put a considerable amount of thought into working out exactly how the shuttle and the sled would operate together. "I put impulse engines on the back of the engine pods," he says, "so the sled can basically fly independent of the shuttle."

◀ The warp nacelles were getting in the way of the docking ring, so Probert swept them forward.

The design of the shuttle itself was intended to be an update of the *Galileo,* which had been seen on the television series. "There was a need to subliminally tie it in to that class of shuttle, just for continuity," explains Probert. "The front was somewhat influenced by that, in that the *Galileo* ships can fly without the need for windows. On this design I totally eliminated the windows on the front

and put kind of what I would refer to as a Teflon coating – a heat shield – there instead. I just put windows on the sides."

When he initially designed the shuttle, Probert was working for Robert Abel & Associates, but by the time the shuttle was due to be filmed, Abel had been replaced by the legendary VFX producer Douglas Trumbull.

▲ The breakthrough came when Probert realized that the shuttle could separate from the warp nacelles. This meant he could design a relatively conventional shuttle. He showed Roddenberry the sketch in the middle of the page and he signed off on the idea.

LONGRANGE SHUTTLE

STAR TREK MINATURE- VULCAN SHUTTLE

◄ Probert produced this detailed drawing of the shuttle itself. He suggested that it wouldn't need windows at all since Starfleet used viewscreens, and that the docking ring would be at the back.

SHOT # 146A — BUT CLOSER + HIGHER

JURAK

ENGINE CUT OFF

SHOT # 146-B SEPARATION

R.P. ACTION IN WINDOWS

SHOT # 146-C ½ GAINER FLIP.

▲ Probert drew these storyboards to show how the shuttle would approach and dock with the *Enterprise*. Trumbull suggested that it should flip over so that it could dock with the bigger ship.

"When Trumbull saw the design, he said, 'Well, there aren't any windows in the front.' I said, 'No, they have viewscreen technology.' 'Hmm,' he replied, 'Sure you don't want windows in the front?' 'No, we really don't need them.' So he agreed to let it go as indicated."

Another of Probert's ideas wouldn't make it through. "I was very tired of gray spaceships, and wanted something different. I thought, 'What would the color gray look like in a red Vulcan atmosphere? It would be sort of mauve, purple.' And that was our base color for the shooting model. It's got this kind of a mauve or warm purple coating with cooler purple panel details."

When the shuttle was painted, the Abel model shop added distinctive yellow RCS (Reaction Control System) thrusters and for the first time ever on a shuttle it had phasers mounted under the nose. These details would survive, but when it came to filming, Trumbull and the producers decided that the purple shuttle was too much of a departure and neutralized the paint scheme so that it came out as a kind of warm grey.

STORYBOARDS

As part of the design process, Probert created a series of storyboards that show how the shuttle would leave the warp sled, and flip over before

docking with the back of the saucer. One of those storyboards showed the shuttle approaching the *Enterprise* from inside the ship through the windows of the officer's lounge. Probert also produced a key frame showing the approach through a different set of windows from a lower deck.

The live-action footage for *STAR TREK: THE MOTION PICTURE* had been completed before Trumbull joined the production, and as Probert remembers, Trumbull was frustrated to discover that the footage had been shot in a such way that he couldn't simply add the shuttle to it.

"There was nothing he could do without reshooting everything, so Doug Trumbull had a very large miniature built of that room, and they filmed the Vulcan shuttle's arrival through those windows."

The last shot shows the shuttle reversing toward the sled through those windows after it delivers its passenger. Neither the shuttle or the warp sled would ever appear again, but it remains one of the most memorable and intriguing cameos ever made by a *STAR TREK* ship and. When asked, Probert said that it was his favorite design for *STAR TREK: THE MOTION PICTURE*.

▲ Probert produced this key frame artwork to show the shuttle approaching from one of the rooms a few decks below the bridge, but this shot was never filmed.

▼ The scenes showing the view from inside the *Enterprise* officers' lounge hadn't been shot in a way Trumbull could work with, so he built a scale model of the room for this shot.

▼ The model of the shuttle was built at Magicam during Robert Abel's tenure in charge of the VFX. Probert was involved in detailing the model during the painting stage and had the opportunity to be photographed with it. The effects were eventually shot by Douglas Trumbull's team after he assumed control of the film's effects.

sternbach
9.91

DESIGNING THE
T'PAU

Designing the *T'Pau* led Rick Sternbach to one or two dead ends before he ditched the warp nacelles and devised an annular warp ring.

▲ Rather than use nacelles, Rick Sternbach came up with a radically different way to power the *T'Pau* to warp speeds by designing an annular warp ring. This gave the ship the distinctly more alien look that he was trying to achieve.

Senior illustrator Rick Sternbach was asked to come up with some designs for the Vulcan ships that were to appear in the *STAR TREK: THE NEXT GENERATION* episode 'Unification, Part II.'

Sternbach began the process by looking at the only other Vulcan ship that had appeared on screen, which was the warp sled created by Andrew Probert for *STAR TREK: THE MOTION PICTURE*. "Since we hadn't seen much in the way of Vulcan ship technology, beyond *THE MOTION PICTURE* shuttle, it was a bit daunting to home in on a true Vulcan style," says Sternbach.

He experimented by fusing the nacelle shape from the long-range shuttle with an older style Starfleet saucer section that was flipped 180 degrees. The result produced a *U.S.S. Reliant*-like feel, with the saucer directly over the nacelles.

At this point, Sternbach was prompted to try a few styles that had less of a Starfleet look. He continued along the path of using nacelles, but the main body became much more like the shape that would later be used for the runabout.

NEW APPROACH

Still not satisfied that it looked alien enough, Sternbach hit on the idea of using a wraparound circular warp generator, or an annular warp ring. This concept would later be used for the Vulcan ships that were designed for *ENTERPRISE*.

"I can't say I was terribly happy with the final result," says Sternbach. "Perhaps different proportions on the annular warp ring, more curves and more positive-negative surface detailing would have made it better. It could have done

▲ Sternbach started off by basing his design for the *T'Pau* on the Vulcan warp sled from *STAR TREK: THE MOTION PICTURE.*

▲ The *T'Pau* studio model was later modified and appeared as Tosk's ship in the *STAR TREK: DEEP SPACE NINE* episode 'Captive Pursuit.'

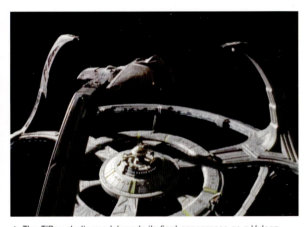

▲ The *T'Pau* studio model made its final appearance as a Vulcan freighter in the *DEEP SPACE NINE* episode 'For the Cause.'

with a few more sketches, but there probably wasn't enough time."

Greg Jein built the studio model based on Sternbach's drawings and it measured 2 x 13 inches. After the model appeared in 'Unification, Part II,' it was modified by Bruce MacRae at Greg Jein's workshop, and used again as Tosk's ship in the *DEEP SPACE NINE* episode 'Captive Pursuit.'

After a few more alterations, this time carried out by Tony Meininger's workshop Brazil-Fabrication & Design, the model made one more outing on screen as a Vulcan freighter in the *DEEP SPACE NINE* episode 'For the Cause.'

The studio model in this configuration was sold in October 2006 at Christie's '40 Years of *STAR TREK: The Collection*' auction for $14,400.

▲ These illustrations show how Sternbach honed in on the final design for the *T'Pau*. The top sketch depicts a more Starfleet-like design, a second foreshadowing the design of a runabout, before the final look takes shape in the bottom two.

DESIGNING THE
VULCAN LANDER

The Vulcans' arrival on Earth is an important moment in
FIRST CONTACT and called for a new and memorable ship.

Remarkably, in 1996, few Vulcan ships had
been seen in STAR TREK. There had been
the unseen U.S.S. Intrepid, in the episode
'The Immunity Syndrome,' the warp sled Spock
arrived on in STAR TREK: THE MOTION PICTURE, and

three tiny ships in 'Unification,' so when production
illustrator John Eaves was asked to design the
Vulcan ship that arrived at the end of FIRST
CONTACT, he had little to go on. He recalls that the
contained little detail. "It was a real vague

▲ The Vulcan Lander
arrives at the end of
STAR TREK: FIRST
CONTACT, ushering
in a new era of peace
and prosperity.

asymmetrical and work in threes instead of twos. That was something that would make it look a little bit different without making a big thing of it."

He also wanted to suggest the sophistication of the Vulcan people. "I thought that the Vulcans' approach to design would be more architectural and artistic as opposed to purely functional, so I started thinking that their ship should be more like a work of art, rather than something that looked as if it was built by an engineer."

VULCAN AESTHETIC

Although there were no ships to give Eaves a direction, there were other elements that had helped to establish a Vulcan design ethic. "I drew some inspiration from the Vulcan outfits because they were very sleek and cool. I wanted to make the design for the ship flow to reflect their robes. It was meant to look kind of proud. Vulcans always have that sort of confident stature."

In the back of his mind, Eaves had another vehicle from a movie he'd just worked on as a modeler. "I had been on *Terminator 2* shortly before and there's a little bit of a nod in the design toward the Hunter Killers. If you looked at them from below, they seemed very proud."

Eaves combined these elements to come up with a ship that he describes as looking like a three-lobed starfish. It was a distinctly organic

description," he says. All it said was 'Vulcan ship.' That's it. They said, 'Make it up and we'll see what happens.'"

Eaves had very little time to think about the design, with concepts needed almost at once, just as he was in the midst of designing countless other pieces for the movie. "I drew up the initial sketch very quickly. Maybe an hour's work went into it. I can't remember what the inspiration was. I think I'd seen a chandelier that I thought was kind of cool."

Eaves recalls that he wanted to give the Vulcan ship a distinctive look that would contrast with Cochrane's ship, the *Phoenix*. This already had the elements that would grow into the familiar Starfleet design aesthetic. "Everything Federation at that point had a very symmetrical design," he explains, "so I thought maybe I'd make the Vulcan ship

▶ When John Eaves started work, the only Vulcan ship seen on screen was the shuttle that brought Spock to the *Enterprise* in STAR TREK: THE MOTION PICTURE, designed by Andrew Probert, but as a shuttle it was of limited use to Eaves.

▶ The only other Vulcan ships were the transports that were destroyed in 'Unification,' but these had barely been visible on screen.

▶ Eaves' first sketch only took an hour or so to produce. It showed a ship that was organic and more like a building than a conventional Starfleet vessel. The sweeping forms were inspired by Vulcan robes.

TOP VIEW

John Eaves 2/96 STAR TREK VIII Vulcan Transport

LANDING CLAW AND HATCH IN FLIGHT, CONFIGURATION OF CLAWS LIFTS TO FORM THRUST RING AROUND THE BASE OF THE ENGINE.

Hatch

▲ Eaves designed the landing gear so that the three legs would swing down, and one of them would contain the hatch the Vulcans disembarked from. When the legs were in the flight position, the feet would form thrust guards for the engines.

design with three sweeping arms. He added some Vulcan writing to the front and presented the sketch to production designer Herman Zimmerman. Just as he did so, Eaves realized that the design might be a little too unconventional for STAR TREK. "I remember Mike Okuda looked at it and said, 'That's not going to make it!' I said, 'Well, I don't have time draw anything else.' I gave it to Herman and he ran over with it. To our surprise it came back with a big tick on it that said, 'Yes. That's great. Go for it.'" Eaves puts some of the radicalism of the design down to the fact that he was fairly new to the STAR TREK franchise.

With the basic design approved, the next priority was to work out the landing gear, which was going to be built practically and used on location so that the Vulcans could emerge from it. "We always knew it was going to land on the surface so we would have to build part of the landing gear practically, but we didn't know how much we

were going to build. We figured it would be one complete leg, but I did a drawing showing the whole architecture. I did that for my own benefit so when it came to doing other drawings, I'd have that piece worked out."

DRAMATIC ARRIVAL
Zimmerman wanted the Vulcans' arrival to be as dramatic as possible, so the art department worked on making the door they emerged from into more than a simple hatch. "We thought, 'Let's come up with a cool door,'" Eaves says, "'What if we make the outside part of the door the ramp, so it slides down and hits the ground to make the entry ramp?' Then you have two doors inside that, which open up. So, it's kind of a triple door."

Since Eaves knew that the legs folded up into the body of the ship, he had the idea that the feet could have a function when the ship was in flight. "We had this idea that the hoop of the horseshoe

JohnEaves 2/96 STAR TREK VIII VULCAN TRANSPORT FlyingConfigurations

foot actually cups around the bottom engine and becomes a thrust guard." He produced a sketch showing this and how the leg would drop to reveal the hatch the Vulcans would walk out of.

The next stage was to work out how the ship deployed the landing gear. "As far as we knew it was going to land and take off, so I had to work out what the ship was going to do as it came in to land or when it took off. I gave them two choices: one where the legs folded down during lift off and one where they folded up. Herman chose the one where they folded up. I remember he thought the other version looked kind of angelical and didn't care for the way the shape turned into a star."

▲ Eaves suggested two alternative ways the landing gear could be deployed. The version on the right was rejected because it made a shape that looked too much like a human figure.

▲ After the art department learned the ship would be created in CG, Eaves redesigned the landing gear so that it spun counter clockwise as it was deployed.

At this stage, everybody in the art department assumed the Vulcan lander would be a physical model, so the mechanics of the way the legs moved were an important consideration. However, *FIRST CONTACT* was being made at a pivotal moment in the history of visual effects and would feature both practical and digital models.

"Originally," explains Eaves, "the idea was that the legs would just drop straight down. Then we learned it was going to be a computer model. I talked to John Knoll, who was the VFX producer at ILM. He said, 'We can do anything. We don't need to worry about hinges or mechanical apparatus to make it work. It's a computer model so we can have any kind of movement you want.'"

SENSE OF MOVEMENT

Armed with this information, the art department decided to add some additional movement to their Vulcan ship to make its approach to Earth look more interesting. "When the ship comes into land, the legs open up and rotate into a forward position," adds Eaves. "So, you had some rotation going on as the legs were lowering. You can see it in the film, but unless you know that's what's happening, I don't think you'd notice it."

Eaves produced a new set of drawings showing the landing sequence with the legs rotating counterclockwise as they dropped. At this point, his background as a modeler came in handy. He freely admits that the ship he had designed was a very complicated shape that he had difficulty holding in his head. "There were too many compound curves for me to figure out what it looked like from different angles," he laughs. "It was scary. Drawing spaceships wasn't easy and I was kind of new to the drawing world, so I built a study model for myself so I could see what it looked like from different angles."

As he built the study model, Eaves worked out a lot of the surface detail, some of which came from unexpected places. "My friend Anthony Fredrickson was the on-set scenic art guy. He said, 'You know a good detail for models is fake fingernails?' I said, 'You're kidding!' but I went and bought a bunch of them and used them to make little shields on the edges of the engines. I used them all over the model. They were a fabulous little asset."

LANDING AND TAKE OFF SEQUENCE *Jim Eaves 5/96* VULCAN T' PLANA-HATH

Although Eaves built the model for himself, he recalls that it turned out to be useful to other people. "Herman saw the model and said, 'Oh my God, that's perfect. Let's send it over to the VFX team so they can work from it.' The model also allowed the producers to see the ship in detail and make changes before the digital version was built. "The only real change we made," says Eaves, "involved the bottom of the engines. I had some inset vents and stuff. When I made the model,

▲ This drawing shows the revised landing sequence, with the landing legs turning as they are deployed until the ship touches down.

Vulcan Landing Gear Detail Star Trek VIII John Eaves 5/96

I made that look a little bit more mechanical. One of the producers, Peter Lauritson, asked to simplify the design and to make it more of a vent because they wanted to concentrate on the light source as opposed to any detailing."

PURPLE AND RED

The art department were also responsible for giving the Vulcan ship its distinctive coloring, which Eaves remembers were based on some Vulcan hand props that they were designing at the same time. "They floated between a purple and a red. Herman had a purple that he liked. I tried to do that on a drawing but I couldn't replicate it with the markers that we had. We knew the ship was going to be purple and we thought it would be cool to have some gold accents. Mike Okuda sat behind me. I asked him what he thought if we put

▲ Eaves knew that part of the ship's landing gear would be built at full-size for use on location. As he wasn't sure to what extent, he drew up the entre undercarriage.

◀ Eaves built a study model for himself, which was ultimately used to refine the design of the ship. The only major change involved simplifying the look of the engines.

some script on it? He said, 'Yeah' and gave me a piece of text. I thought that text would look good in gold in the center. I drew it in there, but it didn't make it on to the final model."

DIGITAL EFFECTS

Eaves worked on another important detail that didn't make it into the film: he created a drawing showing the Vulcan bridge and exactly where it was located. "We didn't know if we were going to show a cockpit or not," he says. "My idea was that those big black shapes on the top were windows. I had been to a laser show at the Griffith Park Observatory. Everyone sits in these kind of dentist chairs and leans back to look at the stars projected on the dome. I thought that would be a cool idea for a bridge – they all sit facing the center then the chairs rotate to look at the ceiling and that's how they pilot the ship. We never

carried it that far, but I did a real, quick rough sketch for it."

Eaves' detailed drawings and his study model were passed to VisionArt, who had previously created some of the Odo morph sequences for *STAR TREK: DEEP SPACE NINE*. Robert Tom painted up Eaves' model and Josh Rose photographed it to make the textures that would be wrapped around their CG model, which was built by Daniel Kramer and Carl Hooper.

VisionArt was also responsible for enhancing the environment that the Vulcan ship landed in. The production had built Cochrane's camp on location in the Cascade Mountain range, which had been burned by forest fires the previous year. VisonArt scanned the live action footage and handed them on to Matte World Digital, where they added trees and painted in a moving night sky that the Vulcan ship emerged from.

▼ Herman Zimmerman wanted to give the Vulcans a distinctive purple color, but Eaves remembers that he couldn't replicate it using the markers he had.

POSITION #4 (LANDING POSTURE) VULCAN LANDER. John Eaves 5/96 STAR TREK (FIRST CONTACT)

▼ The production team decided to build part of one foot for use on location, so Eaves produced this concept drawing to demonstrate what it would look like. Zimmerman asked him to draw up a complicated door to make the Vulcans' arrival as momentous as possible.

JohnEaves 2/96 VULCAN LANDER (Fullsize LANDING-CLAW DETAIL)

◄ The practical part of the foot was built at full-size on the lot before it was transported to the location in the Cascade Mountains.

◄ If you look closely, you'll see that part of the foot is visible in most of the shots the Vulcans appear in.

Direction of Flight

Vulcan Bridge
EXT

◀ Eaves designed the bridge for the Vulcan ship, which he thought could be at the top of the vessel. The ceiling would have become transparent to allow the crew to see the stars.

Bridge (VULCAN LANDER)

CHAIRS ARE IN A ROUND. During Flight the seats recline into piloting mode.

▼ The digital version of the ship (left) was built by VisionArt, who also animated the door opening (center).

The practical landing leg that Eaves designed had also been taken on location. It proved too complicated to make the doors open the way Eaves had envisioned, so the task was also handed over to VisionArt, who created it digitally and added the animation to the live action footage.

The final shot of the film involved a pull back to show the Vulcan lander next to Cochrane's camp. Because the camera was moving, the shot involved some complicated work that was much more challenging in 1996 than it would be today. Special code was written to replicate the camera

▶ Eaves only completed this drawing showing the ship coming int o land after the film was finished. It was used for an article in 'The *STAR TREK* Communicator.'

[STAR TREK First Contact] T-PLANNA-HATH . VULCAN lander John Eaves

move and Ken Evans and Susumu Yukuhiro built a miniature landscape at 1:50 scale, which was combined with a painted background, the Vulcan ship, and live action footage.

The Vulcan lander may only have a few seconds on screen in *FIRST CONTACT*, but it plays a major

role in one of the most important moments in *STAR TREK*'s history. It marks the beginning of everything for the Federation and Starfleet. Its design would go on to inspire the look of Vulcan cities and establish an aesthetic for one of *TREK*'s most enduring species.

▼ The practical scenes were extended with a matte painting that showed far more of the Vulcan ship.

▼ When asked to design a Vulcan survey ship for 'Carbon Creek', John Eaves first came up with this concept, which was inspired by the shape of an American football.

DESIGNING THE

VULCAN SURVEY SHIP

John Eaves designed such great Vulcan ships for 'Carbon Creek' that it was decided it would be a waste to use them just for one episode.

Leading into season two of *ENTERPRISE*, illustrator John Eaves was asked to come up with a design for a Vulcan ship for the episode 'Carbon Creek.' At this point in the franchise, there were few Vulcan ships to refer to in the *STAR TREK* library. However, there had been the *Surak*-class vessel designed by Doug Drexler that featured in the season one episode 'Breaking the Ice.'

"Doug Drexler designed the first Vulcan ship on *ENTERPRISE*," says Eaves. "He set the architectural tone for the Vulcans, so I played off what he had done. I just followed his opened-ring starship, so it would all tie together. The first idea I had came from a football shape cut open like a sandal. The producers liked that idea immediately, so I drew up a couple of color sketches."

In order to gauge a sense of scale of the ship, Eaves was encouraged to design another larger Vulcan vessel, and this led to a further breakthrough. "I also had this piggyback idea of two ships locked together, which came from the US Navy," adds Eaves. "There was this nuclear submarine called the *USS Dallas* that featured in the film *The Hunt for Red October*. On occasion, this submarine had a small Deep Sea

Rescue Vehicle docked onto it for rescue missions. I thought it would be pretty cool to do something similar on a starship, and the warp ring of a Vulcan ship lent itself to having a little shuttle parked in there – the football-shaped shuttle I had designed earlier.

MECHANICAL MOVEMENT

"I also thought it would be a nifty idea if the warp ring folded up and down mechanically. Since we were now creating CG ships, I thought it wouldn't be difficult for them to animate this, whereas before when they had to make physical models it would be hard to rig. I also thought having a mechanical moving ring made it look more retro and this tied in with the fact that it was supposed to be from the 20th century.

"The only problem I had with this design was that when it was shown to one producer, the same one who had flipped the direction of Ru'afo's flagship from *STAR TREK: INSURRECTION*, he started looking at it with a confused look on his face. I quickly ran over and drew a big forward arrow on it to indicate its direction of travel so there wouldn't be any similar misunderstandings."

At this stage, the larger Vulcan ship was known as a *D'Vahl* transport and Eaves drew up an illustration of it with the smaller survey ship docked inside its warp ring. The producers loved this design, but they decided not to use them for the survey ship and the *D'Vahl*-type vessel in 'Carbon Creek.' Instead, they thought the design was so good that they decided to use it for

the 22nd century *D'Kyr*-type vessel that was first seen in the season two opener 'Shockwave, Part II.' It would go on to appear in several more episodes.

UNCLEAR ORIGINS

16 years after 'Carbon Creek' was first broadcast, details of the design for the Vulcan survey ship that did appear in the episode are sketchy. The popular opinion is that lead CG artist Pierre Drolet from Eden FX adapted Eaves' design for the football-shaped survey shuttle. Drolet certainly seems to have used it for inspiration, but the final design did not feature an opened-ring look. It was more of a conventional shuttle shape, which perhaps better reflected a 20th-century design that the episode was set in.

▼ Eaves was also asked to come up with a larger Vulcan ship known as the *D'Vahl* for 'Carbon Creek,' and he thought it would be clever idea if the smaller survey ship docked inside its warp ring. The producers loved this concept so much that they decided to use it for a totally different Vulcan ship – the *D'Kyr* type – which would feature in many more episodes.

DESIGNING
REGULA I

The orbital office complex from the first *STAR TREK* movie was given a new life by making minor changes and turning it upside down.

The design for what would eventually become space station Regula I has its origins in 1978, years before *STAR TREK II*. *STAR TREK* was slated to return to TV, and work had begun on a pilot, 'In Thy Image.' The story opened with the *Enterprise* in spacedock in orbit around Earth, as it prepared to leave on Kirk's second five-year mission. It would have featured Earth's San Francisco shipyards, along with an office complex . The series' art team, led by production designer Joe Jennings and art director Mike Minor, had come up with a design that featured a series of dodecahedrons clustered together in space.

After the success of *Star Wars*, Paramount decided to upgrade their TV project to a movie, with Robert Abel & Associates hired to produce the effects. Abel's VFX art director, Richard Taylor, wanted to upgrade the design of the orbital office complex, so he handed the design to a Andrew Probert to work on.

▶ Andrew Probert designed the orbital office complex for *STAR TREK: THE MOTION PICTURE*. He intended the module at the very top to be the docking control station. Below this were hydroponic pods. Then, a habitat ring, with large windows. The arms that extended from this were living quarters and offices. The area beneath the main core was a factory that made parts for the ships in spacedock.

SPACEDOCK

As Probert recalls, he set about designing an entire orbital shipyard complex. "It was always my hope that you would see more than one drydock in the scene, indicating a large orbital shipyard, with the office complex in the center."

Probert always went to great trouble to think through the logic of everything he was designing. He theorized that in addition to the spacedocks and the administrative center, the shipyards would require a factory where parts were made and somewhere for the staff to live as well as work.

"I finally hit on the idea that the offices would be combined with the orbiting factory," he explains, "which would manufacture parts for the ships as needed. So at the bottom of the complex you'd have a factory, and below that you'd have a power source."

Probert placed a habitat module at the center of his design and then balanced the proportions

▲ A selection of Andrew Probert's early designs for the orbital office complex, which would have been surrounded by ships in spacedock. He originally wanted the station to be 'taller' and to have a power plant at the bottom, but this was eliminated during the design process.

▲ The model of the orbital office complex under construction at Magicam in 1978 before its appearance in *STAR TREK: THE MOTION PICTURE.*

by designing a series of large tanks that extended above this. "At the very top of the structure was dockyard control. Then the vertical tanks below that are hydroponic gardens, which would supply a lot of the food and oxygen to the station. There's a ring at the base of those with windows in. That was a recreation space that would have gardens and open areas – various spaces where the crew could come together and enjoy large vistas into space. Below that you'd have a series of pods that go out horizontally. The offices are on very long extensions, and the residential areas on the short extensions. When you see it in the movie, they're continuing to build part of it – that's a residential pod." As the design evolved, the VFX team eliminated the bottom part of Probert's design, but otherwise the model was constructed much as he designed it.

REPURPOSING

When ILM took over the effects work for *STAR TREK II*, they decided that they could re-purpose the orbital office complex to become *Regula I*, the station where Carol Marcus was developing the Genesis Device. As supervising modelmaker Steve Gawley recalls, "We were given the task of making it look different. We took it apart and put it upside down, then reattached some of the outer pods in a different way." ILM also added an antenna to

what was now the top of the station, removed the office pods and added an observatory dome to one of the habitat pods.

ILM also added an animated sequence of lights to the hangar bay. ILM's Marty Brenneis outlines the process: "They wanted these animated lights that run in a sequence across the top of the bay. I made modifications to the system so that the camera could 'talk' to the model. That was the first time I ever did that, but after that it became a standard thing."

By the time the team was finished, the office complex had been completely reborn and, appropriately, given a new lease of life as the home of the Genesis Project.

▲ This piece of Tom Lay concept art shows Regula I in orbit around the Genesis Planetoid. Note the nebula in the background.

▼ The ILM team adapted the model for its appearance in *STAR TREK II* – turning it upside down and upgrading the lighting.

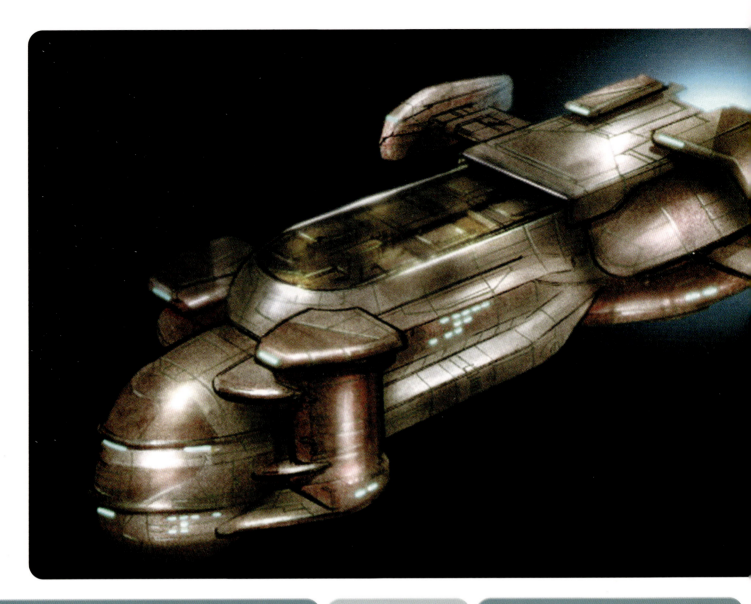

DESIGNING THE
S.S. LAKUL

The *Lakul* and its sister ship the *S.S. Robert Fox* were designed at ILM, where they were almost an afterthought.

As the *U.S.S. Enterprise* NCC-1701-B is about to be launched, she receives a distress call: two transport ships are caught in a mysterious energy ribbon. Even though she is barely spaceworthy, the *Enterprise* responds. She is too late to save one of the ships, but manages to

beam the survivors from the other, the *S.S. Lakul*, aboard at the last second.

The dramatic sequence that opened *STAR TREK GENERATIONS* was designed by Industrial Light & Magic's Mark Moore. "I started off as a storyboard artist," recalls Moore, whose early work included

▲ The *S.S. Lakul* was designed by ILM's Mark Moore and appeared on screen just long enough to be destroyed by the Nexus ribbon.

▲ ILM VFX staff. From left to right: Mark Moore, John Knoll and Bill George.

The Hunt For Red October. "Then I moved up to art director, which is what I was on *GENERATIONS,* so I was deep in the mix, which is where I wanted to be. Bill George and John Knoll were the supervisors. We were, of course, *STAR TREK* fans. *NEXT GENERATION* was a big thing for me."

▲ Moore's storyboards were created to show how the Nexus ribbon interacted with the ships caught in it. The *Lakul* was only added as a placeholder and he didn't expect to actually design the ship.

Most of the ships and props in *GENERATIONS* were designed by the art department at Paramount rather than ILM, but as Moore explains, the *Lakul* was an exception.

REPURPOSING

"Most of the time everything has been designed, but when it comes to visual effects, sometimes things will slip through the net," he explains. "When that's a ship design, that's great, because it's what we all want to do. That happened with the *Lakul*."

The Nexus ribbon was one of the major effects in the movie so it was natural for ILM to design it. Moore remembers spending a lot of time coming up with the look of the ribbon. He produced storyboards, and this was where the *Lakul* first appeared. "There was a scene with the *Lakul*. I was doing storyboards so I roughed a version of it in as a placeholder. I didn't really think about it. We just had to show that there was a ship that was distressed. We were concerned about how the ribbon was going to interact with the ship."

▲ Moore was thrilled to have the chance to design a ship. Using the placeholder he had put in the storyboards as a starting point, he sketched out a series of possible designs. He and Bill George both liked the version on the bottom right.

PERSPECTIVE

SIDE VIEW

SECTION OF ENGINE

When the ILM team was ready to take the effect to the next stage, they realized that no-one had designed the ship. After a brief conversation with illustrator John Eaves and production designer Herman Zimmerman, it was decided that ILM should take it on, and the job was handed to Moore. "We finished the storyboards and then before we actually built it in CG we had to decide what this ship looked like. At that point I had a little more time on my hands so I could do the whole spectrum of designs as we tried to work it out."

Moore expanded on the rough sketch he'd included in the storyboards. "My first four designs were variations on that. It was a little sleeker and smaller, so after a little bit I decided I had to make it bigger and bulkier. I went from sleek to kind of bulky to very bulky.

"I was trying to keep all the designs in the *STAR TREK* universe. The nacelles are a big part of that. I maybe got hung up a little bit on that. *Voyage to the Bottom of the Sea* was a huge influence on me as a kid. If you look at some of the drawings, you can see the *Seaview* in the front."

FURTHER DESIGNS

Before long, Moore had identified a shape that he and Bill George liked, so he worked it up in more detail. "I liked the very front heavy feel of this design, where the nacelles balance the back. I've got my little *Seaview* as the rear fins, but the bulk of the ship was in the front. Bill wanted to see what the forms were, so I drew a lot of form lines to show what the shapes were doing. The nacelles have a curved inside. I thought that was a neat look."

Although Moore and George both liked the design, others weren't convinced and it fell out of favor. Moore produced another round of thumbnails as he looked for a new shape. "When that design got rejected, I was asking myself what I should do next. I'm really into the retro sci-fi stuff so

▲ Moore and George were both very pleased with the design they submitted to Paramount, which had the familiar *STAR TREK* nacelles but a very different sense of balance. However, the producers in LA asked them to think again.

▼ After his first attempt was rejected, Moore sketched a new series of thumbnails. His design was influenced by a 1930s aesthetic. He started to think of the ship as being a larger, more utilitarian passenger ship. Before he could finish the design, he was called away to work on other projects and the job was handed over to another concept artist, Ed Natividad.

I started over with a kind of 30s streamlined look. I hadn't seen much of that in *STAR TREK.*"

At this point Moore was promoted to creative director of the ILM art department and was pulled away from work on *GENERATIONS.* "Life got hectic," he recalls. "I came back to it later and started afresh. I believe that in the meantime, Bill George carried on working with Ed Natividad. He was a super-talented storyboard artist who came in. They worked out the final look."

Natividad took the basic lines of Moore's new approach to the design and added twin nacelles, supported by wings at the back. When Moore returned to the project, he completed the design by producing drawings showing the model in four alternative color schemes. The model was then built in CG for its brief appearance in the film.

TREK 7 'LAKUL' DESIGN
7/94 ILM M.Moore

TREK 7 'LAKUL' DESIGN
6/7/94 ILM M.Moore

◄ Moore returned to the project in time to finish off the design of the *Lakul*. He took Natividad's finished design and produced a series of alternative color schemes.

DESIGNING THE SON'A
FLAGSHIP

Ru'afo's ship was inspired by a horeshoe and a piano, and would get completely turned around by the VFX team.

The script for *STAR TREK: INSURRECTION* called for an entirely new alien race with new costumes, new makeup and new ships. The details of what the Son'a vessels looked like would be left to Herman Zimmerman's art department. Zimmerman handed the job of designing them to concept artist John Eaves.

When the art department started work, they didn't have a full script, just a document called a beat sheet, which laid out all the major action points of the movie. "The beat sheet," recalls Eaves, "said we needed a flagship for the Son'a

leader Ru'afo, and some battleships. We started with the battleship. The first sketches I did were all for that. We figured that Ru'afo's ship was going to be a smaller version of that, so it would evolve from all the groundwork we did now and we would get to it later."

Because the Son'a were an entirely new race, Eaves couldn't start by adapting familiar designs, as he had done for the Borg on *STAR TREK: FIRST CONTACT*. He had to come up with something new. As he explains, inspiration for starship design can come from the most unlikely places. "You look

at anything and you can see a spaceship in it. We didn't have any architecture to fall back on and I wanted to give a whole different kind of look to the Son'a designs, so I went with yard toys. My daughter was very big on rodeo at the time, and we had horseshoes all over the property. The other thing we had were lawn darts, which were these big darts, like hoops, that you throw at posts. On top of that, we had just got *The Road Warrior* on laser disc and the boomerang was a big thing in that. I remember thinking, 'I can turn these things into spaceships.'"

Eaves started the design process by making a series of loose sketches in blue pencil. "The sketches are just roughs trying to break out a shape that I like," he explains. "You'd do the blue pencil and then you'd ink over the top of it so you didn't do a hundred drawings. Once I had done that, I'd present it to Herman, who would say 'Yay' or 'Nay.' At this stage I was trying to figure out what kind of shape I was going to go with. Thinking about the yard toys, I had the idea that the battleship could be a stretched out horseshoe."

▲ John Eaves started the design process by producing a series of loose sketches in blue pencil. These early sketches were meant to be for the Son'a battleship, but he was confident they would also evolve into Ru'afo's flagship.

Even at this early stage, Zimmerman would walk past Eaves' desk and comment on his work, giving him guidance and pushing him in the direction that he wanted. "Herman said, 'Let's make these ships rather flat because they are flying through this area called the Briar Patch.' Some of the sketches I had done had a little depth to them, so I shrunk that down and we ended up with more of a boomerang shape."

THE FIRST DESIGN

Eaves also rejected some approaches because they looked too much like the Breen warships he had designed for the final season of *STAR TREK: DEEP SPACE NINE.* Eventually, he had something that he thought showed promise, so he inked it up, giving the design more detail.

At this point, he added an important element that would become a feature of Son'a design. "We had been to a music room where there was an open piano. I had looked inside at all

the intricate strings and keys, and I thought it would be cool to incorporate that into the design of these ships."

After years of working with producer Rick Berman, Eaves knew that he tended to respond well to designs that had echoes of one of *STAR TREK*'s most famous ships, the Klingon *Bird-of-Prey.* The shape he worked up was clearly inspired by a horseshoe that had been bent in the middle so the sides formed wings.

Zimmerman took this drawing to the producers, who approved it as the basic direction for the design. Eaves recalls he wasn't completely satisfied with it himself. "I wasn't happy with it. I was happy with some of the lines. I thought, 'I'll work on the boomerang idea for the battleship. I'll park this and work on Ru'afo's ship.'"

As Eaves started work on Ru'afo's flagship, he kept the same basic shape from the drawing that had been approved, but made the ship bulkier and more curved. "We made it rounder because

▶ Once he had a design direction he liked, Eaves inked over one of his sketches. This design was then approved by the producers.

that created a real nice contrast with the *Enterprise*," he says. "The Son'a weren't an overly aggressive race so we didn't want have to have lots of sharp angles. We wanted them to be militaristic without being aggressively militaristic. The organic approach fitted pretty well with that. At the same time, I was watching the costumes coming together and what Mike Okuda was doing with the graphics. They were going more organic, so I mimicked that with the exterior."

ROUND AND MUSCULAR

Although Eaves made the design rounder, it wasn't soft. Instead it was muscular with sharp pincers at the front. This was a deliberate attempt to represent Ru'afo's personality. "We knew that Ru'afo was kind of an arrogant, headstrong guy so we thought, 'Let's make his ship the most

aggressive of the fleet,' so he got the angles and the bridge was higher than on any of the other designs because he sits above everyone else."

Eaves wasn't working on Ru'afo's ship in isolation during this bust period: the Son'a ships were all being designed at the same time, and it was important that it looked as if they had all been created by the same species. "We were doing four ships at once," he explains. "We had the collector, the battleship, Ru'afo's flagship, and the shuttle that drops the drones. We were trying to tie everything together so there were elements that flowed back and forth between all the ships. There was a big fork on the top of the battleship that was reflected on the collector. We tried to make Ru'afo's ship similar, but independent. The common trait between all the ships was the keyboard detailing."

▲ Eaves took the basic shape of his design and created a rounder and more muscular version, which he thought would suit the personality of the Son'a leader.

On Ru'afo's ship, Eaves took the musical idea further. When he was adding detail to the design, he found various gaps that needed to be filled. "There are harp strings in there and organ pipework. The little openings lent themselves to that. The whole thing is a giant flying instrument. Everything about it was kind of inspired by music. I didn't plan it, but the opportunity presented itself, and I thought it was fun to throw that in."

When Zimmerman took Eaves' designs to the producers, they were approved with few changes. The next stage was to send them over to the modelmakers. On *INSURRECTION*, the process was very different to Eaves' experiences on *FIRST CONTACT* or on *DEEP SPACE NINE*.

"This was going to be the first full CGI *STAR TREK* movie," says Eaves. Peter Lauritson was the producer in charge of effects. We were using

Santa Barbara Studios and Blue Sky/VIFX. There were miniatures made for that strafing scene at the end, but everything else was CG. This was my first time working with CG guys, so I didn't know how they approached stuff.

ADDITIONAL DETAILS

"If I was working with ILM or a traditional modelmaker like Greg Jein, I could just draw a three-quarter view. It wouldn't have to be accurate and I could leave a lot of it blank so that the modelmakers could be creative themselves. Santa Barbara wanted a lot of information on these ships. These guys were primarily used to doing organic and atmospheric work. This was their first big project where they did ships as well. They would call up and say, 'Any information you can give us – whatever it is! More

▼ This sketch shows the finished design of Ru'afo's ship. It was originally meant to fly from right to left, and Eaves added the energy trails after the VFX team decided it should fly the other way round.

SONA" Ship John Eaves 2/98 COOL AND BLUE GREY Combinations with DarpGun Metal tones in the recesses
STAR TREK 9 of 10 COLOR PASS #1

BODY SCULPTURE Studio

VARIATIONS OF SON'A
FACE STRETCHER
FOR BODY SCULPTURE
STUDIO.
(INTEGRATED WITH HEADREST).

ED NATIVIDAD
3·17·98 STAR TREK IX
SON'A FACE STRETCHER.

The interior of Ru'afo's ship called for two major sets: a bridge and a plastic surgery studio, where the Son'a would undergo face stretching procedures and Admiral Dougherty would meet his end.

For production designer Herman Zimmerrman, the centerpiece of the surgery was the Son'a surgical bed. "The bed that our Admiral Dougherty gets murdered in – the face-stretching machine – is a difficult physical prop to make work right. It had to do a number of things and seem to do them automatically, when in fact it all had to be done by off-camera wires and lights. We needed more lead time than we actually had at our disposal. That was the one prop that, because of the schedule, we had to have early on. We made a number of trips, the property master and I, out to the company that was building it to check on the progress; we had to make sure it fit both the actors that had to use it. All of that

requires some careful attention, which it got.

"We actually did take the skin off the face. When you first see Ru'afo, his face folds up around the nose and all the way up over his eyes, that whole flap of skin, is just being put

back on by two attendants. We were more able to do it on the drawing than we were in actuality, given the difficulty of that prop. What you see on screen is what we were able to make of that idea."

ED NATIVIDAD
3·17·98
SON'A BODY SCULPTURE

COMPRESSION PADS HOLDER
IS CONSOLIDATED WITH
HEADREST.

ARM OF FACE STRETCHER IS
RECESSED INTO WALL AND
IS NOT OVERTLY MOUNTED
TO EXAMINING CHAIR.

STAR TREK IX Flagship "the otherside" 3/4 view John Eaves 4/98

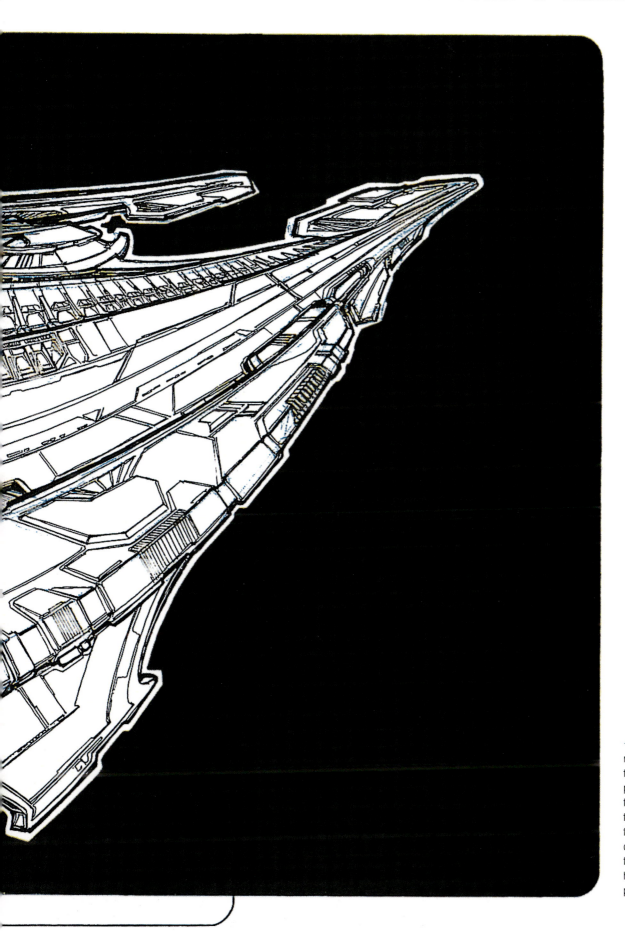

◀ This drawing was meant to show the ship from behind, but VFX producer Peter Lauritson thought it made sense for the shoulders to fly forward. If you look closely at the details at the back, you can see harp strings and the pipework from an organ.

"New Improved" Ru'afos Stellar Cruise Vessel John Eaves 4/95

▲▼ Eaves produced detailed plan views for the CG modelers, who struggled with all the ship's compound curves.

will be better than less!' They requested tighter views and plans and any visuals."

As a result, Eaves produced a series of detailed drawings showing Ru'afo's ship from above, below

WITH OUT NACELLE

WITH NACELLES

WITHOUT BLADE

WITH NACELLE BLADE

and from the side. He even produced a side view drawing that showed what the ship would look like without its 'warp blades.'

"I always think, 'If you had to build it practically, how would these things fit together?'" he outlines. "I try to illustrate how things connect, and to show the layering. On Ru'afo's ship, the nacelles actually feed into the ship at two points; they float like very narrow catamaran pods. So I did a drawing for them showing it with and without them."

Eaves also supplied a detailed paint guide that called out the colors for the different parts of the ship. He thought that would be the end of his involvement with the design. Since they were armed with his detailed drawings, the team at Santa Barbara Studios didn't feel the need to ask any more questions and the approval process for the VFX models didn't involve the art department.

"We'd see the rough models if we got over to see dailies, which was not that often," recalls Eaves. "The first time we saw Ru'afo's ship it was flying the wrong way round! I had always meant it

▶ These renders of the original Santa Barbara Studios model show the ship from the side, top and front.

▶ Eaves produced this scale chart to show the relative sizes of all the ships that appeared in *STAR TREK: INSURRECTION*.

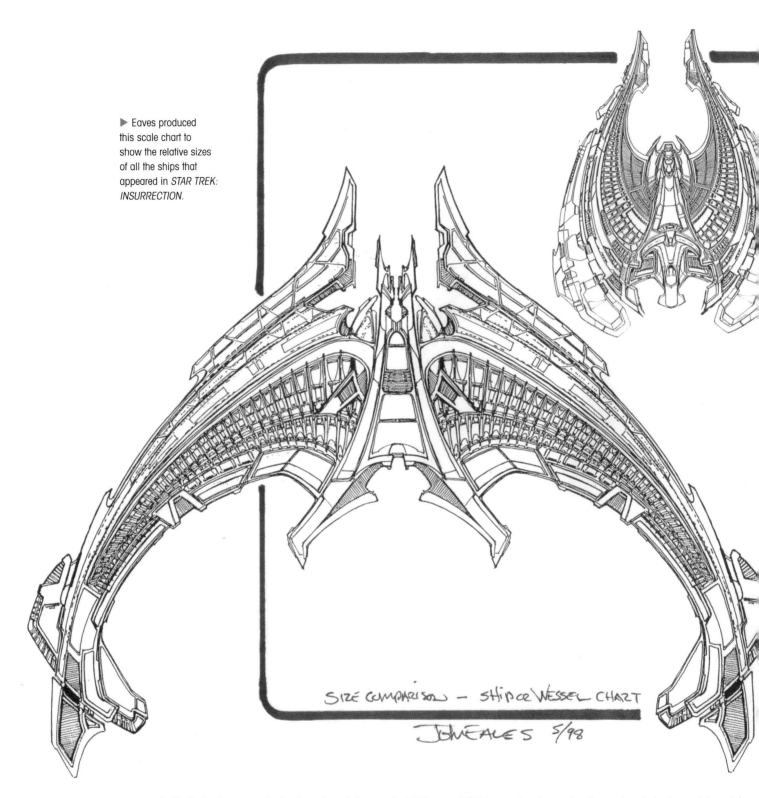

SIZE COMPARISON — SHIP or VESSEL CHART

JOHN EAVES 5/98

to fly forks forward, but when I sent it over to VFX, I forgot to indicate that on the drawing. I ran over to Peter's office and said, 'Hey, it's flying the wrong way!' He goes, 'I thought it looked better the other way.'"

DIRECTION OF TRAVEL

There were some implications to the changes the VFX team had made. Eaves had designed the ship with the impulse engines at the back. More importantly, instead of facing forward, the bridge was now nestled in the rear of the ship. But there were costs involved in changing things at this point. "It had been going the wrong direction for quite a while before we found out!" Eaves remembers. "They had already done a couple of finished

▲ Eaves returned to the original sketch that had been approved and used it for the Son'a shuttle.

make some subtle changes. "We had to rework the engines so they worked the other way around, so the Bussard collectors became the warp engines. Luckily, they never did a shot showing the view from the bridge window."

SINGLE APPEARANCE

Since that day, Eaves has added arrows to his designs showing the intended direction of travel. Another problem that came up was that the ships seemed to be changing size from shot to shot, so Eaves produced scale charts showing the relative size of all the different ships in INSURRECTION. Ru'afo's ship scaled out to 1,160 feet long.

The finished models only appeared in INSURRECTION. The film wrapped up the Son'a's story so they never appeared again.

The CG models themselves were never passed over to the VFX team at Paramount, and with Santa Barbara Studios folding some time around 2002, they are likely to be lost. As a result, the Son'a ships are an unusual tangent in the STAR TREK universe: a series of significant designs that only appeared once.

opticals by that point. I fought for redoing them so it went the more aggressive way. They understood me, but it was a pretty heavy discussion and eventually we decided to leave it as it was. If you don't know you couldn't tell, but I still feel that it's going backwards!"

Knowing that the direction the ship was flying in had to be reversed, Eaves revisited the design to

STAR TREK "NEMESIS
SCHIMITAR
CHARLES'S ELITE BATTLESHIP

◄ This sketch shows John Eaves' final concept for the *Scimitar*. The design was also worked on by another concept artist, David J. Negron Jr and the man who made the 3D model, Rory McLeish.

DESIGNING THE
SCIMITAR

Shinzon's ship was described as being a breathraking vessel that was like an enormous spider and dwarfed the *U.S.S. Enterprise.*

STAR TREK: NEMESIS was built around the conflict between Captain Picard and his clone, Shinzon, and introduced us to one of the darker corners of the *STAR TREK* universe – Romulus' sister planet Remus. Shinzon had been brought up in the darkness of the Reman dilithium mines before rising

to power, taking control of the Romulan senate and making peace overtures to the Federation. As concept artist John Eaves explains, Shinzon's flagship, the *Scimitar*, was designed to reflect his personality. "The *Scimitar* has a very aggressive shape. It was an extension of Shinzon's personality. That was the

attitude that inspired the design. That's where all the sharp angles, the very, very deep color and the dark shadowed areas came from. It was who he was. Their whole planet was dark and based in shadows."

John Logan's script described the *Scimitar* as a massive vessel that would

▶ Eaves' first design for the *Scimitar* was inspired by the work of John Berkey. Eaves describes it as looking like a predatory fish. It was rejected because it didn't obviously look like a spaceship.

▲ From the beginning the brief described the *Scimitar* as unfurling like a spider.

◀ For a long time, the *Scimitar* had spindly arms that curled over from the back to fire the thalaron radiation.

take on the form of a spider when it was poised for attack. To Eaves's amusement, Logan described the *Scimitar* as 'unlike anything we have ever seen before,' an instruction that was frequently given to the art department over the years.

Eaves and another concept artist, David J Negron Jn, both began work on the design process. The two men worked in different buildings, but would talk to one another and ultimately collaborated on the look of the ship. They were also responsible for the design of the new Romulan warbird, the *Valdore*.

Eaves' first design was inspired by the art of the late John Berkey, an artist who was famous for his work on sci-fi

book covers, and on the movies *2001: A Space Odyssey*, *Star Wars* and *Dune*. Several of Berkey's ship designs were based on predatory fish, and Eaves used this as a starting point. However, the producers felt that the shape he came up with was too 'ambiguous,' so he returned to the classic Romulan *Bird-of-Prey* for inspiration.

"Since Romulus and Remus were sister planets," explains Eaves, "I was trying to morph the design of the Bird-of-Prey into something new rather than develop a whole different type of architecture. I figured the Remans took Romulan design and made it more angry."

Eaves next drawing was rejected on the grounds that it was too literally like a hawk. Eventually, everyone settled on

a heavily faceted design that Eaves felt owed a lot to the Klingon *bird-of-prey*.

SPIDER LEGS

From the beginning, Logan's story involved the *Scimitar* unfolding its wings as it deployed a deadly weapon. "The script said the wings opened up like a spider," Eaves remembers, "so at first we had this idea that the *Scimitar* was going to house these rods that would come out from the back of the ship. Very thin, spider legs would come together and hold this weapon at the front."

Negron spent some time working out how the wings could articulate as the ship attacked. He turned out a variety of sketches that were very obviously spider-like. One variation that showed

▼ David J Negron Jr also worked on the design, concentrating on different ways that the *Scimitar* could spread its wings.

▲ This design was reminiscent of Andrew Probert's original concept for the Romulan Warbird, which had vertical rather than horizontal wings.

▼ Other concepts showed the *Scimitar* spreading its wings like giant sails.

the wings splitting so they could fold into position above and below the ship gave it the look of Andrew Probert's original design for a vertical version of the Romulan Warbird. In other versions, the wings folded down to make a point below the ship or formed a series of arms that folded out from the back.

UNFOLDING WINGS

Around the same time Eaves made a sketch where thin arms unfurled from the body to hold a weapon in front of the ship. "The producers thought that looked too spindly," says Eaves, "so we came up with the idea of breaking up the wings into six or seven different pieces that would fold out. There's one big main wing; the majority of the other wings are stacked on top of that, and there's one secondary wing on the bottom."

Since Eaves came from a traditional modelmaking background, he automatically thought about how the articulation Logan's story called for could work in a very mechanical way. However, ultimately the wings operated in a way that could never have been built practically.

"When I was doing the sketches," adds Eaves, "I would collaborate with the visual effects house Digital Domain. A guy named Rory McLeish was doing

▼ This design was rejected on the grounds that it was too literally birdlike.

the work on the *Scimitar*. We made a real quick study model to show them in an open position. Domain did all the modeling showing how the wings would hinge out. This is one of those things they would never be able to do in a practical model because there are multiple hinge points on each wing; they don't just fold at one point, they're multifaceted. They all had unique start and finish points."

When Eaves looked at the finished design, the shape reminded him of Picard's lionfish Livingston, which hadn't been seen since *FIRST CONTACT*. "Ironically from the front when you look at it, it looks like Livingston," he laughs.

▲ Eaves' 'final' design for the *Scimitar* was based on the familiar outline of the Klingon *Bird-of-Prey*, a shape that he knew appealed to the producers.

▶ At this stage the *Scimitar* had 'spindly' spider arms that were used to fire the thalaron weapon.

▶ This drawing shows the top down view of the *Scimitar*, which had deliberate similarities to the Romulan *Valdore*.

"It's almost like he left Livingston behind, so that's his nemesis!"

McLeish also made a significant contribution to the look of the front of the *Scimitar*. Eaves' original version had a very flat front, but as he and McLeish worked together, the front became more involved as it filled up with weapons.

"Rory did his own version of what that front end would look like. It's a very organic, almost Gothic look, with all these bristling weapons. It's almost like looking down on an evil cathedral."

Eaves was also working on the design for the new version of the Romulan Warbird, the *Valdore*, and he was keen to make sure that there was a link between them. "If you look down on the top view of the *Valdore* and the *Scimitar*," he says, "it looks like one could morph into an evil version of the other. That was the thinking behind it."

Other aspects of the design were influenced by the work that the art department was doing on the interior sets. Eaves and Domain keyed in to the

dark color palette that was developed for Shinzon's control room, giving the exterior a gun metal look that had rarely been used on *STAR TREK*.

SOMETHING MISSING

Eaves remembers that long-time STAR TREK colleague Doug Drexler stepped in to help out. "When it came to the texturing, Doug came on and he worked out how the panels were going to look. He did a matte/gloss variation for them so even though the color is the

ame, the surface finish determines
e way it looks when light hits it."
 The design was all but finished but
e producers felt that there was still
omething missing.
 "They described it being like an
complete sentence," recalls Eaves.
hey wanted a final little push in the
ffect so when it's in the final open
osition with the wings split open and
ese focusing devices come out,
most like a cat whipping out its
aws before it attacks."

◀ The final solution was
to break the wings into
different facets that were
hinged so they could 'fold
out.' Each smaller wing
had a unique design.

DESIGNING THE
ARCHER'S TOY SHIP

Archer's toy ship was a collaborative process between illustrators Jim Martin and John Eaves as *STAR TREK: ENTERPRISE* began production.

The opening shot of 'Broken Bow', the first episode of *STAR TREK: ENTERPRISE*, is an extreme close up of one of *STAR TREK*'s most unusual ships. The young Jonathan Archer's toy spaceship model features extensively in the narrative of 'Broken Bow', a representation of the future *Enterprise* captain's fascination with space travel and the close relationship with his father. The toy ship, which later returned in the season three episode 'Similitude', was designed as a collaborative process between illustrators

John Eaves and Jim Martin as *ENTERPRISE* entered preproduction in 2001.

"Jim and I had both just started on *ENTERPRISE*," recalls Eaves. "Our job roles hadn't really been decided yet, and so we were both doing props, both doing sets and both doing everything. "I'd been off *DEEP SPACE NINE* for a year-and-a-half, and (production designer) Herman Zimmerman called us all back in."

Jim Martin started his career as a PA on *DEEP SPACE NINE* in 1992. After working up to

▲ Jim Martin's final concept illustration for Archer's toy ship that received approval from production designer Herman Zimmerman and the producers.

the position of production illustrator, he left the *STAR TREK* franchise in 1995 after briefly contributing to *VOYAGER* to pursue freelance opportunities in feature films. "One of my regrets is that I was maybe young and impatient back then," laughs Martin. "Looking back, I really wish I'd stayed longer. To actually work on a *STAR TREK* TV show at Paramount is pure gold. Then I got a call from Herman because they were starting up *ENTERPRISE* and they needed another illustrator."

STARTING WORK

With Martin and Eaves working side by side to conceptualize *ENTERPRISE*'s new visual approach

to the *STAR TREK* universe, an early assignment was to look at concept art for Archer's toy ship. This unusual ship was designed in concert with potential historical starships to feature in the series' opening title sequence.

"We know that what Herman had in mind was stuff for the opening credits," explains Eaves. "He felt that whatever didn't work for the little model would transfer over to the opening credit ships that we were working on, so there was this double meaning behind it."

"John was doing the shuttle for the opening sequence," Martin takes up the story. "I was looking at those, and I keyed on that for my

▶ A selection of Jim Martin's initial thumbnail sketches for the toy ship in blue pencil, his favored technique at the beginning of the concept process.

▲ Martin's first detailed pass at the ship following the initial sketch phase. The illustrator was asked to give it the charm of a toy for his second and final pass at the concept.

first pass. It's following in John's general concept of a streamlined, clean lifting body shuttle, which is what he was doing for the opening."

"I had a friend who worked in the museum at Edwards Air Force Base," continues Eaves. "I asked him what the future of Edwards' space-bearing vehicles might be. And he pulled out this thing called the VentureStar. That was going to be the space shuttle replacement, but that project didn't happen. We were really majorly influenced by what the guys at Edwards had to show us."

"The VentureStar was definitely the reference that was kicking around back in the art department," confirms Martin. "Let's make it feel we're not at warp speed yet, this was humanity's transitional period."

DESIGN BRIEF

With work underway, Martin ran with the design for the toy spaceship, producing initial 'blue pencil' sketches. "You'd get your pages where there's a brief description in the script and then Herman would talk you through where he'd like the design to go before you do a first pass," he outlines. "That helps him think about it as well, because it becomes visual. I start with the silhouette, working out what feels right for the basic shape. It informs you about the rest of the design.

Jim Martin
Enterprise - Pilot Episode
Paramount

▲ Martin provided a plan view of the toy spaceship to give the modelmakers as much detail as possible to work from.

◄ A John Eaves concept illustration of the anti-gravity motor to be fitted into the toy spaceship. This would ultimately remain unused, the final design being created by Jim Martin.

◄ John Eaves and Jim Martin both worked on concept illustrations for the toy spaceship. This John Eaves concept was produced in March 2001 as part of development for the title sequence and the ship that became the *S.S. Emmette*. It features the twin nacelle design that would also be seen in Jim Martin's final design.

LINDA PARK

▶ In addition to the toy spaceship itself, Jim Martin produced concepts for the remote-control unit used by the young Jonathan Archer in 'Broken Bow'.

It grows organically from thinking about the silhouette and the shape to the ones that really are triggering the deeper thought until you get your design on its feet. Sometimes, even when you're three-quarters of the way there, you hit a sticking point and go back to your thumbnails. You pore over them and find one that you inadvertently answered a question to without even knowing it in a quick scribble.

"Then you get further design input on where Herman would like to see you take it, and that's why there are a couple of later versions. That first one really didn't land, Herman wanted the charm of a toy, something that you put your action figures in. That's where the second pass came about, which was the one that landed with him and the producers. And that's why Herman Zimmerman is the production designer that he is!"

One further stage in Jim Martin's design process was to provide a detailed plan view of the final

Within the sketch:
#5

JOHN EAVES 8/01
STAR TREK "ENTERPRISE"
opening credit →
Concepts After Space Shuttle / Before Phoenix

◄ Side-by-side comparison of a final shuttle image from the opening titles, and the corresponding John Eaves concept sketch. The toy ship was developed as part of the same process.

ship. "It wasn't something I'd have done back in my early days," he explains, "but having worked on feature films where you were responsible for the design but then had to prep the model maker or the prop master with some pretty dead on drawings, to get them started. That ended up being part of my process when I came back to ENTERPRISE."

ANTI-GRAV

In addition to ship concepts, Martin and Eaves were also responsible for coming up with new props for the show. Jim Martin worked on the concept illustration for the toy ship's remote-control handset unit, while John Eaves did a first pass on the ship's anti-gravity motor prop.

"That was one of the first things Herman had me do," remembers Eaves, "and it sat around for a little while. Herman said, 'Oh, Jim made this beautiful little round one that fits in, so we're going to go with that one'. I think we

used that later in another episode and just recolored it."

"I didn't know how much this ship was going to be featured," continues Martin, who was thrilled with the finished physical prop that was made in Paramount's model shop. "I saw the episode and thought, wow, there it is. I also love the segment where Archer's painting it with his dad. They even kept the ring on the front of the nacelles. I love that detail."

"It was a fun ship," sums up John Eaves. "Jim and I had done a lot of stuff, but never together, but on ENTERPRISE we actually got to work together, which was a treat. Jim is just brilliant, I love working with him."

"John kicked the toy ship down to me and I appreciate that," says Martin. "ENTERPRISE really was his show, he's a real talent. I was only there on the first few episodes and I don't want to take anything away from him, and it was nice for him to kick this one to me!"

◄ John Eaves's final design of the *S.S. Emmette* featured circular rocket engines. He also added surface detail to the belly of the ship, which matched the pattern found on *Enterprise* NX-01.

DESIGNING THE
S.S. EMMETTE

Illustrator John Eaves was asked to come up with a design of ship that could be a prequel to *Enterprise* NX-01 for the main titles of the show.

The origins of what became known as the *S.S. Emmette* began a while before illustrator John Eaves started working on concept designs for *ENTERPRISE*. He had drawn a stunning illustration of various pioneering craft from history, alongside iconic fictional ships from *STAR TREK* blasting through Earth's atmosphere and into space and the stars beyond.

When Eaves did start working on *ENTERPRISE*, he gave copies of the poster to executive producers Rick Berman and Brannon Braga. "It appeared that I had hit on an

◀ This was an early alternative design for the *S.S. Emmette*, but it was felt that it looked too advanced for what was needed. The main body was still Delta-shaped, but featured more angular lines. Some elements were adapted as part of Archer's toy ship in 'Broken Bow.'

idea for the opening titles of *ENTERPRISE*," recalls Eaves. "Purely by coincidence, Mr. Berman told me that they were thinking of doing something similar for the opening of the show. They wanted to have a sequence that took you through a journey of historical milestones that eventually ended in space and laid witness to the world of *ENTERPRISE* and *STAR TREK*."

MISSING LINK

Once this idea had taken hold, the producers realized that they needed another fictional *STAR TREK* ship for it to work, and they asked Eaves to design it. "A ship was called for to bridge the gap after the *Phoenix*," says Eaves. "It

▶ Another of Eaves' alternative ideas for the *S.S. Emmette* featured a series of 'blocky' panels, which together made up a more traditional Starfleet ship shape.

▲ Before Eaves started working on *ENTERPRISE*, he drew up this stunning poster, which featured many real-life legendary craft alongside ships from *STAR TREK*. When he presented the poster to Rick Berman, he was told that the producers had been thinking about creating a similar idea for the opening titles of *ENTERPRISE*.

▲ Nearly all the concepts that Eaves came up with for the *S.S. Emmette* featured a ship with a Delta-shaped saucer. This was one that had more of a half-saucer design, but it was felt that it resembled *Enterprise* NX-01 too closely.

needed to be more advanced than the *Phoenix*, and to carry us a step further before the big reveal of the star ship of the show – Doug Drexler's mighty *Enterprise* NX-01."

After receiving the brief, Eaves pulled out his pencils and set to work. "We knew the ship was going to feature in a fly-over sequence, and so I drew a whole bunch of variations from the rear angle," he explains. "Some of them had nacelles up and some of them had nacelles down; others had rectangular engines and some had round. I gave the producers a whole series of drawings that they could pick from. Most of them featured a Delta-shaped main body with wings on them, as I felt that design connected best with the architecture of *Enterprise* NX-01.

Some of the concepts that I drew were perhaps a little too advanced for what was needed. But, it was great working on ENTERPRISE because I could resubmit drawings that I had done for one thing and they could be chosen later to represent another ship entirely.

"The producers ended up choosing a design for the *Emmette* that had a mixture of engines at the back. It also had nacelles which featured grilles in the ends of them, similar to how they had been on the original *Enterprise* studio model from 'The Cage.'"

ROCKET ENGINES

The fact that the concept chosen featured massive circular rockets at the back certainly helped sell the idea that this was an evolution from the *Phoenix*, but not as advanced as *Enterprise* NX-01. It was a natural fit to fill in the gap between the two vessels.

Once the concept had been approved, Eaves further refined the drawing and added more detail. "Although I knew that the ship would only be seen from the rear flying over

a Moon base, I also did a higher three-quarter view that had a lot of the NX-01 elements in the paneling," says Eaves. "That way, you had a breakdown of how the belly of the saucer would look. There was a definite tie-in with the line work that would take you right from this little ship to the one you saw after – *Enterprise* NX-01."

Once Eaves had finalized his illustrations, they were sent to the effects house Foundation Imaging where CG artist Rob Bonchune created the model. He only built the rear of the vessel, knowing that it would only be shown from behind. Before this, the ship did not have a name, but at some point around this time it was labeled as the '*S.S. Emmette*.' Although no one could quite recall the reason for this designation, it stuck.

Eaves was pleased with the final design. "It was a fun, easy little project to do," he sums up. "There wasn't a lot of direction, which meant I could sort of make up what I wanted on it. The producers went for the design and it worked out really well."

▲ This was the illustration that the producers picked for the design of the *S.S. Emmette*. Eaves drew several alternatives for how the rear engines of the craft could look, and the producers thought that the powerful circular rocket engines best suited the needs of the ship they wanted.

▶ This illustration drawn by John Eaves became the final design of the *OV-165*. Eaves added the 'United States' lettering and called it the Orbital Star, but they were left off the final CG model that appeared in the opening titles.

DESIGNING THE
OV-165

John Eaves researched the future of Space Shuttle design when he was asked to invent a suitable craft for the opening titles of *ENTERPRISE*.

Once an idea had been established for the opening titles of *ENTERPRISE*, the producers asked illustrator John Eaves to come up with two ships that would fill in the missing pieces between the real-world Space Shuttle and the fictional *Enterprise* NX-01. One of these ships became the *S.S. Emmette*, which slotted between the *Phoenix* and *Enterprise*. The second eventually became known as the *OV-165*, and it

fitted between the Space Shuttle and the *Phoenix*. This was a transition design that would bridge the gap between the Space Shuttles of the early 2000s and what would come in the near future.

FIRST CONCEPT
One of the first concepts Eaves devised had massive booster-style rocket exhausts, a pointed front end and a bulbous body with a single fin on top. This sketch was felt to be headed in the

right direction, but the producers wanted something that tied more into Starfleet architecture.

Eaves followed this with a second drawing that featured a craft with warp nacelles and a more angular main body. This steered more towards a Starfleet aesthetic, but looked a little too advanced. Eaves resubmitted this drawing when he was asked to come up with a design for the model spacecraft for the young Archer.

◄ One of Eaves's early ideas was much more *STAR TREK*-like in that it featured warp nacelles. It was felt that it looked too advanced for what was needed, but Eaves resubmitted the design for the toy model used by a young Jonathan Archer in 'Broken Bow.'

◄ This was Eaves' first idea when he was asked to come up with a ship for the near future. It was felt it needed to be more tied in with *STAR TREK* architecture.

#3

#2

VENTURE STAR

Meanwhile, Eaves had contacted a friend who was stationed at Edwards Air Force Base in California to ask him what NASA was working on to take over from the current Space Shuttle. He was told that the VentureStar, a single-stage-to-orbit reusable spaceplane, was in development. When Eaves looked into this proposed spacecraft, his ideas for what was needed for the title sequence became much clearer.

Eaves drew up several alternative designs for an advanced Space Shuttle that were based on the VentureStar, but he added more *Enterprise*-like detail to the body panels to tie it into the world of *STAR TREK*.

The producers selected one of these concepts, as they felt it best connected the route of present day spacecraft with how *STAR TREK* envisioned the future of starships.

For his part, Eaves enjoyed the challenge of the task and was delighted with the finished CG model, especially as it was seen in the main titles docking with the International Space Station.

#4

_Eaves 8/01
STAR TREK "Enterprise"
opening credit concepts
After SPACESHUTTLE / Before phœnix

◄ Once Eaves had learned about NASA's VentureStar project, he drew several concepts that were based on that ship. The producers chose the middle drawing, labeled '#2.'

"REGENERATION" BORGIFIED STARFLEET VESSEL
JohnEaves 3/63 ENTERPRISE II

▲ John Eaves' design shows a much smaller Borg ship than we have seen befor, so the textures are much larger and draw inspiration from the makeup and costume designs for the Borg drones.

DESIGNING THE

ARCTIC EXPLORER

For 'Regeneration,' John Eaves designed a ship perfect for Arctic exploration, and that could be assimilated by Borg drones.

From the beginning the Arctic Explorer involved creating two distinct designs: the Starfleet version that visited Earth's poles and a version that had been assimilated by the Borg.

John Eaves recalls that he began by sketching out the Starfleet version. "The ship started off as a transport to get from the Starfleet base to the site," he says. "They obviously had a team of these ships because we designated a patch for the side of it. They were doing all kinds of Arctic exploration. I decided it would be a mix of a snow plough, a helicopter and a big Arctic exploring vehicle. A combination of things that I thought would be appropriate for that job, yet put in the Starfleet era.

Then as it gets taken over most of the changes take place in the back of the ship."

At the time, Eaves says he had been designing a lot of ships that were taller than they were wide and he wanted this one to be "more horizontal". It was also important that it looked suited to landing in the Arctic. "We all agreed it needed to look like a ship that had a purpose rather than something odd. It was designed for a softer, fragile landscape like snow or ice and the script called for it to have landing gear."

Eaves remembers being inspired by a vehicle he'd seen in a copy of *The Guinness Book Of World Records*. "It was the longest vehicle in the world; it had these segmented pieces and it was built for the Arctic," he recalls. "It used to be parked in Yuma, Arizona. It really wasn't a visual inspiration but I remember seeing that and thinking it would be kind of cool to try and incorporate elements of it. I also had a matchbox snow plough when I was a kid. It was a little red thing with white treads and I tried to incorporate a little bit of that into the

▶ The unmodified version of the ship was something rarely seen on *STAR TREK:* a small transport. Eaves remembers that at one point it was armored, but the producers decided that this wasn't a good idea.

▶ During the course of the episod, the ship is assimilated by the Borg and turns into something quite different.

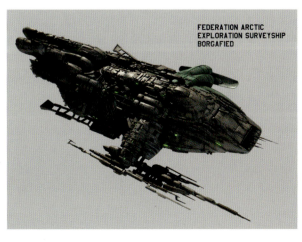

FEDERATION ARCTIC EXPLORATION SURVEYSHIP BORGAFIED

design. So it has a little snowmobile, and a little bit of the old DC3 with the Arctic skids on it. It was a mix of fake and real.

SKIS AND SKIDS

"Giving it the ski attachments sold the point that it was an Arctic ship. We're instantly familiar with skis and skids – anything else wouldn't work. I did a drawing where it's making the discovery in the snow with a little campsite and stuff, so that was the very first phase. Once that got approved, then we took the ship into the Borgified world."

IN FLIGHT 3/4 VIEW
GEAR UP POSITION

FRONT VIEW GEAR UP (inflight)

FRONT VIEW GEAR DOWN (LANDED)

REGENERATION, #49
ARCTIC EXPLORATION EARTH VESSEL
ENTERPRISE, SEASON II JOHN EAVES 2/03

When it came to modifying the design as it was assimilated, Eaves says it was important that the audience could see it was still the same ship so he just applied the Borg texture to the front, while the rest of the ship underwent a more radical transformation. "The back grows into all kinds of crazy configurations while the front makes it possible to know what ship you're looking at."

MAKEUP INSPIRATION

After his work on *FIRST CONTACT*, Eaves was familiar with Borg design, but this was a much smaller ship, so this time he drew inspiration from Michael Westmore's design for the Borg makeup. "I figured it's a smaller scale so I'll go with the smaller kind of Borg detail. On the hull of the ship you can see this little tiny circular area. That's like the implant the

Borg technology spread from, kind of like the Borg implant that came out of Picard's face when he's in the dream. I just took that as the inspiration for the ship. It had all the little intricate pieces."

During the show the ship became more and more assimilated; Eaves recalls producing a series of drawings that show how extreme the Borg detail could be. "I think I did four variations," he says. "Some were too light and some were too busy, so we went with one in the middle that had a good sense of Borg growth without being overwhelming.

"We provided drawings for two stages of Borgification. I did a light version and then this version and a couple that went way beyond this. The back was getting to be enormous and out of proportion where it was definitely going to grow into something bigger..."

▲ Eaves began the process by designing the unmodified version of the Arctic Explorer – known as *Arctic One*. This drawing, which shows it on the ground with a small campsite around it, was the one that was approved.

Quick Sketch - Borgified Exploration Vessel

FEDERATION ARCTIC
EXPLORATION SURVEYSHIP
BORGAFIED

◀ Eaves supplied the VFX artists at Eden FX with drawings showing the Explorer in various stages of assimilation. They worked out the detail and created two different versions in CG.

◀ By the end of the episode, the back of the Explorer had become much larger as the Borg 'grew' more technology.

▼ The Suliban ships were designed by John Eaves, who had returned to *STAR TREK* to work for production designer Herman Zimmerman.

DESIGNING THE

SULIBAN CELL SHIP

On *ENTERPRISE*, the Suliban would use small, one-man ships that were designed to connect to one another to create larger vessels.

When *STAR TREK: ENTERPRISE* launched, the producers wanted something new and different. The Suliban were a major new race of antagonists, with very different technology. Instead of large and aggressive starships, they operated tiny vessels that were barely large enough

for a single pilot, but which would combine to make larger ships. As concept designer John Eaves remembers, the first time the art department heard about this concept, they didn't get the whole story.

"We got the beat sheet in the morning, and that said there was a new

alien race with small ships. Straightaway (production designer) Herman Zimmerman and I came up with some fluid, curvy designs. We took them to the meeting the same day where a broader beat sheet was provided. The description of the alien ships in that was much more detailed and specific. That

▲ John Eaves' first designs were produced before he even had a full brief. He knew that the Suliban ships were meant to be small, but had no idea that they were meant to connect to one another. He and production designer Herman Zimmerman came up with a curvy, organic design. A few hours later they got the full brief and this first design pass was consigned to the waste basket.

had the whole thing about ships docking together, so this whole rough idea was abandoned."

Eaves was working on the design for the *Enterprise* NX-01 at the time, but he was struggling to come up with a design that gave the producers what they wanted. The decision was made to take him off that and to put him to work on the design of the cell ships instead.

"The cell ship really wasn't a difficult piece," he recalls. "We had all the don't

dos right up front, so it was pretty easy to follow the path and make this thing come out. They didn't want anything asymmetrical, and after that meeting we knew that they had to connect together. I started to look at a circular design, but you've seen that so many times. I thought if I did something with a bunch of facets and angles on it, that would allow the ships lots of ways to connect to one another. Flat surfaces can open up like a hatchway into the

other ships, so you're not limited to one hatch at the back and at the top. The design I came up with was kind of like a STOP sign – an octagon shape with ten flat sides that you could dock with."

This design proved to be enormously flexible: the cells could be used to make almost any shape and had, as Eaves says, a "mathematical feel" that pleased everyone.

"Herman thought this was really great and worked really well. Once we'd

▶ Once Eaves knew the ships had to connect to one another, he started to look at different shapes, including a spherical design. These earliest designs had circular clamps or docking ports.

▶ On the next round of designs, Eaves started to explore the idea of giving the ship lots of flat surfaces that could connect to another, making it easier to build complex shapes.

John Eaves 9/01 Star Trek # 945 Cell ships "Coxpots"

C A B
open Closed

figured out that quick shape, that one went through the approval process pretty fast."

SURFACE DETAILS

While the basic shape was agreed rapidly, there was still work to be done working out exactly how the ships would dock with one another and refining the look. "It was mostly the surface detailing that changed and that took time to get approved,says Eaves. "It was all about that and how the facets were going to work – what would be a hatch and what would be a window. It's got kind of insets on the side. We knew we were going into the CG realm so we didn't have to do practical miniatures and practical sets. They built one for real, but when it came to the visual effects, we had this brand new world where we didn't have to worry about things being static. So we did all kinds of versions

▶ One of the ideas was that the different faces could pop out so they could latch into one another.

▼ The design that was approved had ten flat faces and a cross-section that Eaves describes as being like a STOP sign.

where the plates on the side would actually lift off or pop up and expand. Nothing of that nature made it to the final version but we drew versions where all these things could extend out like bumpers."

SPINNING AROUND

When it came to the interior of the cell ship, the art department returned to the idea of a spherical design, with Eaves producing a design that could be built as a practical set.

"You know those exercise wheels you can get into and those gyroscopes that roll inside themselves? This was how the cockpit is inside of it. It had this kind of rolling motion, so no matter what the angle of the ship was, the pilot would always be upright. His seat would roll so he's not spinning. He's stationary while this ship kind of rolled around him."

Laughing, Eaves says that the color of the ships was the result of the last job he

Flying in a group

Cell ship
in FLIGHT

HATCH
opens in

Cell ship
opens when Docking.

JOHN EAVES 3/01 STAR TREK EPISODE ONE Cellship Concepts

◀ The next phase of the design
involved working out how the
cell ships would connect,
what shapes they could
make and what kind of
surface detail would work best.

Connected Flying

Cell ship
in flight

HATCH
opens in

Cell
Ship
(opened)

Docking
mode

◀ Since the cell ships
would be built in CG, the art
department knew that hatches
could appear and disappear,
and parts could move without
the need to replicate this on a
practical model.

Double sized Cell ship

◀ Eaves produced
drawings that showed
what the cell ships would
look like when they
combined, starting with
a simple double unit.

Various
Cell ships in scale to each other

▶ This illustration
shows that the cell ships
came in different sizes,
meaning they could be
combined to create even
more complex shapes.

◄ The controls of the
cell ship were designed
to be very different
were reminiscent of
a gunner's turret.

John Eaves 01 Cellship Control Console

► This abandoned
concept shows a design
for two larger cell ships,
and how they would
dock together.

LARGER SCALE
CELL SHIPS
(Docked)

CONSOLE AND SEAT Rotate independently of Cellship.

STAR TREK Cell ship piloting chair

had before starting work on *ENTERPRISE*. "I had just come out of (the movie) *Ghosts Of Mars,* so I had all these deep reds and browns in my marker box. I pasted that on top of it and they liked that color right away. It's not the Klingon color; it was more like a deep kind of moody red with deep warm browns in it. It was literally by accident that I had those colors in the marker box. I had gallons of that red ink and it was a case of just using it."

HELIX

The cell ships were only part of the story. "The cell ships were pretty easy," Eaves says, "but the big Suliban ship – the Helix ship – was just as hard as the NX-01. It was a nightmare to do. I think me and Doug (Drexler) spent the same amount of time trying to iron this out."

As Eaves recalls the 'Helix ship' started out as a conventional design, but as it evolved, it was decided it should be made up of hundreds of the smaller cell ships.

"I think I drew about 40 or 50 different variations of it," he laughs. "It wasn't until the thirtieth one that they said 'Well when we say helix, we don't really mean *helix.*' I remember that conversation really well! I said, 'Well what do you mean when you say helix?' Then later on they went back so saying 'Actually, when we say helix we mean helix.'"

The final design had a long, thin central core that the cell ships connected to. "The full-size ship was kind of cool to see. There's really not much of a ship underneath the Helix – it's just the cell ships; that's what makes the whole thing. Eden FX made a beautiful CG model on that."

Looking back, Eaves is amazed at the number of drawings that were produced, something he says would only happen on a pilot when the team had the time to refine the concepts so much. The result was an enormously flexible design that was *STAR TREK's* own equivalent of a LEGO brick.

The Suliban freighter was designed by John Eaves, who had also designed the earlier Suliban ships.

Suliban Cargo Ship #4
ENTERPRISE H'
CRASH LANDING #42 12/02

DESIGNING THE
SULIBAN FREIGHTER

The Suliban freighter was made up of existing ships that were combined in new and interesting ways.

Suliban ships had always been designed to be modular and combine to create something larger. In *ENTERPRISE*'s pilot, that had manifested in the form of a massive helix made up of hundreds of smaller cell ships. When concept artist John Eaves saw that the script for 'Future

Tense' called for a Suliban freighter, he pulled out his drawings of the existing Suliban cell ships to see how he could use them. As he explains, the cell ships came in two shapes. "There's one I always think of as being like a STOP sign. Then the other one is more of a lozenge shape."

Since the Suliban's ships were modular, Eaves' first thought was that the Suliban freighter would basically be a frame that was then filled up with the smaller ships, which would carry the cargo. He produced two concepts that worked along these lines. In the first concept, a single 'spherical' cell ship

▼ Eaves started work by looking at the existing designs for Suliban ships. His idea was that the freighter would combine them to make a new ship.

Various Cell ships in scale to each other

became the head unit, while the rear of the ship was made up of the lozenge-shaped versions. The second concept was much wider and had lozenge-shaped ships stacked on either side of a central frame.

CONVENTIONAL DESIGNS

These drawings went to the producers, but were rejected. "They wanted something like the conventional freighters we'd seen," says Eaves,

"like the *ECS Fortunate*. They asked for a truck hauling stuff. That was always how we seemed to go with freighters, right back to the Cardassian one I did for *DEEP SPACE NINE*. That works well as you can immediately see it's a freighter."

For the next round of drawings Eaves produced an open framework with a head unit and a long spine that supported a series of cargo modules. He abandoned using the existing cell ships in favor of more conventional

▲ Eaves thought about making the ship by combining the existing cell ships, which was something that had been done for the Suliban helix in 'Broken Bow.'

Suliban Cargo Ships
Crash landing # 42
John Eaves '02

Ⓐ

Ⓑ

▶ Eaves' first concepts
involved frameworks that
were filled with — and, or
– towed by cell ships.

cargo units. "I gave them the docking ports that are on all the Suliban ships. As long as I had that and the Suliban color, I figured I could do what I wanted."

SWINGING PENDULUM
However, when Eaves presented this design, the producers told him they felt the pendulum had swung too far.

"They thought that looked too spindly and was too far away from the other Suliban designs," he remembers. "So

they asked me to look back at the helix and make it look more Suliban."

The fourth concept that Eaves produced used a series of the lozenge shaped ships which were connected to one another in a cross with the 'spherical' cell ships in the middle. The whole thing was held together by a frame that created a spine.

"I actually did a sketch where they were 'helixed' a little bit," laughs Eaves, "but it started to look complicated and I

remembered how long it took to get the helix approved, so I opted out of that!"

Eaves passed his sketch on to Eden FX, where the model was built by Pierre Drolet. The design underwent some major revisions, as the team eliminated the cell ships in the middle that held everything together.

"There was quite a bit of difference between my drawing and the version on screen, but what they came up with looked pretty cool."

Súliban Cargo Ship #3
Cramett Handling #42 ENTERPRISE
Joe Eaves /12

Súliban Cargo Ship #4
enterprise 11
CRAM HANDNG #42 [signature] /02

◀ After the initial design was rejected, Eaves looked at a more conventional style of freighter, with an open frame that would contain pods.

◀ Eaves suggested using the established Suliban color scheme so that it was obvious who was operating the ship.

◀ For the final design, Eaves reverted to something that combined the cell ships. In this version, there were 'spherical' cell ships running through the center.

▲ This was the design that illustrator John Eaves came up with for an Arkonian military vessel. Later, its belly-mounted gun was removed and the cannons at the sides were transformed into smaller nacelles to turn it into a Xindi-Arboreal starship. Finally, after a color change, it was used again to depict a Tellarite cruiser.

DESIGNING THE
TELLARITE CRUISER

A bonnethead shark was the inspiration for a starship that ended up being used on three separate occasions on *STAR TREK: ENTERPRISE*.

▲ The Arkonians, who had lizard-like skin, featured in just one episode of *ENTERPRISE*. Their military vessel made only a brief appearance when it intercepted *Enterprise* NX-01 near a planet the Arkonians had annexed.

The Tellarite cruiser was a reuse of a design that had been seen twice before. It originally appeared in the episode 'Dawn' as an Arkonian military vessel, or, as the production staff called it, a destroyer. It was then used as a Xindi-Arboreal starship, before it finally featured as the Tellarite cruiser.

John Eaves, the resident *STAR TREK* illustrator at the time, remembered that the producers just wanted a general alien attack vessel for its initial outing.

"The producers didn't have any specific requirements," says Eaves. "That was okay because it happened most of the time. I drew quite a few quick pencil sketches for the producers to choose from. Once they had picked what they liked, I came up with a few more detailed drawings that I did with a black line marker."

One of the designs that Eaves created was based on a bonnethead shark. They are a species of

hammerhead shark, but have a smooth, much more rounded spade-like head, just like the front of the Arkonian vessel that Eaves drew. "I didn't want it to be too obvious that I'd based its design on a shark, so it didn't have dorsal fins on it, said Eaves. "Although, a shark's tail goes upright, and that's where the vertical engines at the rear came from.

"I also remember I had a running architecture going on in *ENTERPRISE* at that time. There was a gap between the

ENTERPRISE #39 – DAWN
ALIEN ATTACK VESSEL

VERSION "A"

▲ Eaves was particularly pleased with the vertical arrangement of the exhaust pattern he designed, because it meant the ship could be easily recognized from the rear. He was always looking for ways to distinguish alien ships from *Enterprise* to make it easier for the audience to tell them apart at a glance.

body and the front of the ship. We were able to do open space with CG, but you couldn't do that with physical miniatures because it threw up big optical issues. I always liked that positive and negative space, and this was one of those ships that allowed us to do that. This was not that long after *STAR TREK: NEMESIS* and the Romulan *Valdore* had the same thing with open space after the neck. It was just like a little art trend I had going at the time."

ALTERNATIVES

This design was ultimately chosen, but Eaves also came up with two more designs. One had a wedge design, and Eaves likened it to the A-wing interceptor from *Return of the Jedi*, with exposed engines and blaster cannons on the side. The wedged front was actually based on a tool for splitting logs that Eaves had seen in a catalogue.

The other design he worked up was based on a pelican's beak. His

mother-in-law had an unusual pencil drawing of just a pelican's beak on a wall in her home, and Eaves thought it would make a really cool shape for a ship. This version also had a more conventional rear end, rather than the vertically-stacked engines he had given to the other designs. Where possible, Eaves always liked to give the producers a choice, just so he would not be accused of forcing them to take just one particular direction.

ENTERPRISE #39 DAWN
ALIEN ATTACK VESSEL
VERSION "B"

◀ Eaves also came up with this design for the 'alien attack vessel,' but it was never used. Eaves based the wedge-shaped front end on a tool he had seen that was used for splitting logs.

In this case, Eaves preferred the design that the producers selected. He liked that it had a very distinctive front and back end. He always felt that alien ships should look noticeably different than the hero ship, so the audience would not confuse them visually. Having an unusual exhaust pattern at the rear went some way to achieve that goal here.

Once a design had been chosen, Eaves would move on to his next assignment, and he often did not see the finished CG ship until broadcast. This was fine by him, as was the fact that they sometimes reused a design. This was mainly down to saving money, particularly on episodes that featured many special effects. Thus, the Arkonian vessel became the Xindi-Arboreal starship after its belly-mounted cannon was removed, and then a color change later it became the Tellarite cruiser.

◀ The ship was seen for a second time when it was used to depict the Xindi-Arboreal starship. In this slightly changed configuration, it featured in two episodes – 'The Council' and 'Countdown' – where it was dwarfed by the vessel used by the Xindi-Aquatics.

DESIGNING THE
ORION INTERCEPTOR

The Orion interceptor was designed by John Eaves, and evolved in different directions, including a version intended to be crewed by the Gorn…

▲ John Eaves' initial concept for the ship that would become the Orion interceptor was a design that had been proposed several times during the course of *ENTERPRISE*.

John Eaves is one of the *STAR TREK* franchise's most prolific and long-serving members of design staff, contributing to both TV series and movies dating back to *STAR TREK V: THE FINAL FRONTIER* in 1989. After working for four seasons as production illustrator on *DEEP SPACE NINE*, Eaves contributed designs to *STAR TREK: NEMESIS*, before joining the staff of *ENTERPRISE* in 2001 for the entire run of the series. For the 2004 episode 'Borderland', Eaves was tasked with designing new ships belonging to the Orion Syndicate, bringing the

Orions back to *STAR TREK* for the first time in 30 years. However, early drafts of the script by Ken Lazebnik featured a different alien race from THE ORIGINAL SERIES.

During development of 'Borderland', the reptilian Gorn, as featured in 'Arena' and an episode of the 1970s *STAR TREK* animated series, 'The Time Trap', were intended as the script's central antagonists. With this in mind, Eaves first turned to a ship design he had put forward for consideration several times in the past. "This was actually a ship that came

and went at least seven times during the course of *ENTERPRISE*," he says, looking back to early preproduction meetings for 'Borderland'. "It would never make it, but they always wanted to see it again. We had a very quick meeting when we got the 'beat sheet' (for 'Borderland'), so I just threw that together real quick. I went into the meeting with it, and they said, 'Oh… we like that one, but not for this particular production!' The earlier iteration of that first design goes way, way back to the first season of *ENTERPRISE*. And it would come up again."

GORN DESIGNS

With that first design given a positive response, but again rejected by *ENTERPRISE*'s production team, Eaves quickly provided two alternative designs, once more with Gorn as the intended crew. These concepts were smaller in scale than the first interceptor design, envisioned as faster, lighter fighter craft. "There wasn't an awful lot of information on it," explains Eaves, "and so my thinking with the Gorn was that it was a small crew and a small ship, and that's where it came from. We were experimenting – well I was – with that

multiple triangulated design." This experimentation in design also gave rise to the earlier vessels of another *ENTERPRISE* antagonist. "That's where the Xindi started from too, that multiple triangulated design. The first of those designs, you've got that three-point structure and the engines wrapped all around it, and the bridge was a little diamond in the centre." The second of this pair of designs saw

▲ Eaves' second design concepts for the then Gorn ships were envisioned as smaller, fighter-sized vessels.

◄ The second designs were put forward to the color stage, adding detail including some hull decoration to make the ships distinctive.

▲ Eaves adopted a more segmented, heavily armed design concept after the Gorn were replaced by the Orions for 'Borderland'.

a first move towards taking inspiration from nature. "We did more of a shark fighter. I liked these a lot," adds Eaves.

"We then had to do a color sketch," Eaves continues. "We started playing with the painting on the outside. They wanted to have a marking, not nose art, but some kind of exterior marking." At this stage, Eaves looked into military history, taking the external markings of the World War II Curtis P-40 Warhawk fighter plane as inspiration for the Gorn ship's exterior adornment. "Teeth are always a good thing to start off with. And

these were still Gorn ideas. At some point in development it changed to Orion, so the whole Gorn fighter thing went away."

ENTER THE ORIONS

With 'Borderland' now featuring the return of the Orion Syndicate, Eaves took a fresh approach for the next stage in the design process for the new ship. "This was very organic and kind of pickle-in-a jar-ish," he describes this next design. "That was the idea behind it, that it was just these multiple layers of stuff. Nothing segmented, but all just

◀ Color stage. Eaves was inspired by ships in the film *Laputa: Castle in the Sky* for this stage.

tied together and in a globular form with battle guns all over it."

Eaves' influences as a film fan informed his direction for this stage of the design, taking the 1986 Studio Ghibli animated movie *Laputa: Castle in the Sky*, as a starting point. "It's one of Studio Ghibli's very first films," explains Eaves, "and they had these zeppelins, that I just thought were the coolest things, with all these battle guns and stuff all over them. And that was the inspiration for this because I had just picked up the Laserdisc of that movie. I thought it was the coolest thing, the way they made these flying battle ships with these guns all over this kind of curvy, round zeppelin shape."

The script for 'Borderland' contained little in the way of description of the Orion interceptors. "They said in the beat sheet that is was heavily armed, and that was about all the description there was. That can mean just about anything," laughs Eaves. "On *ENTERPRISE*, we were going for that retro look. So this stage might be super retro, but it's still fun to put turret guns all over the place."

After producing the sketch concept of this more globular design, Eaves proceeded to add color as before. Here, the process covers two different versions, highlighting the continuing evolution of the design – a first, clean variety, followed by a second color sketch incorporating the exterior teeth image of earlier designs. "I was just carrying it

on, because they still liked that exterior artwork on the ship."

LESS BULBOUS

Exterior decoration would remain a constant through to the final design of the Orion interceptor, but the more bulbous, compact version was further refined, first as a black-and-white sketch. Eaves outlines the thought process behind this stage: "Let's see something a little more compact. They liked the bulbous look, but less bulbs. This had a little bit more of an aggressive shape to it, it still has all the guns and the battle weary stuff going on, and then we went to another color version of it. These were all presented at around the same time, maybe a couple of days apart."

In adding more exterior decoration to the ship's hull on both these later designs, Eaves happened upon a way to add unusual detail by accident. "I was just learning Photoshop back then," he says. "I had just picked up a David Bowie album, where Bowie has tattoos on the cover. I thought it would be cool to tattoo a ship, and that's where that weird marking comes from. So we created this Bowie-esque/Deborah Harry tattoo thing on the outside. I hit something in Photoshop that outlined the text, and I couldn't figure out how I did it! But luckily I did it on both of them, and it did this weird outline. It preselected the color and it sampled off

▲ A third version of this stage added teeth decoration, brought forward from earlier design concepts.

▶ After further discussion, Eaves came up with a less-bulbous, but still heavily armed interceptor concept.

▶ A further color stage, adding more detail and the same exterior hull decoration theme as seen before.

what I had there. I thought, holy smokes! I hope I can figure out what I did! I didn't for years! But that's how that started and how that whole tattoo look was primeval and kind of cool."

NEW DIRECTION
The design concept for the Orion interceptors was quite far advanced when a sudden change of

direction was taken, influenced by a production meeting for the episode. "I think it was the writer (Ken Lazebnik), who at the meeting said, 'I found a picture of something that I think could be even better than these two ideas.' So he brought out a picture of this bizarre battle axe…"

This moment was pivotal in quickly moving to the final design, with Eaves working up two fresh

Harrad-Sar's heavy cruiser "Orion" (version two) Star Trek: Enterprise #93 (Bound)
John Eaves 1-05

Harrad-Sar's heavy cruiser "Orion" (version one) Star Trek: Enterprise #93 (Bound)
John Eaves 1-05

▲ John Eaves further refined these two advanced designs, adding more dynamic detail in Photoshop to make the Orion ships even more fearsome. As the above design sketches show, they would later be put forward by Eaves as potential designs for Harrad-Sar's Orion cruiser in the later *ENTERPRISE* season four episode, 'Bound'.

concepts that were larger and even more aggressive than earlier designs. The increased scale was crucial. "There was another issue, when you're having a space battle in a STAR TREK show, the bad guy usually is at least the same size as the Enterprise, or bigger, unless it's a scout ship or something else. You'll never see anything that's smaller in scale at that time. It always had to be equal in scale, and it didn't matter what the firepower was, there just had to be a visual comparison.

"The design with the six blades was first," outlines Eaves. "The battle axe had two blades, so I just extrapolated that and took it to six. I didn't care for that sketch, so I thought we'd just go back to the two blades. They really gravitated towards that two-blade version, so we went full color on it"

Getting very close to the final, locked design, the color stage of this advanced version incorporated elements of hull decoration as in earlier stages of the design process, once again

adopting the teeth motif across the wing section. "They said, 'why don't you take the teeth and put those on it, and the tips of the wings, dip them in blood'. We wanted it to be aggressive not only in nature but also in appearance, so it was just a giant flying bully threat!"

The design process was lengthier than usual for a new STAR TREK ship, demonstrating the ongoing visual evolution of a technical, fast-moving weekly television drama. However, few designs are ever wasted, and the earlier, more globular design concepts for the Orion inceptor were ultimately looked to as the basis for Harrad-Sar's Orion pirate ship in ENTERPRISE: 'Bound', later in season four.

"This one is a full gambit of different ideas that went all the way up to the end," Eaves sums up work on one of his favorite design assignments for ENTERPRISE. "It's a good example, too, of how the scripts change as you go. You draw from one element to the other based on just a couple of words changing."

▲ After experimenting with a six-bladed configuration (see opposite), Eaves ultimately settled on a more bird-like design with two wide, sweeping wings. Note the interceptors' larger scale in relation to Enterprise, which has been added to the sketch at this stage.

▲ With a new direction suggested by writer Ken Lazebnik, Eaves produced a dramatically different design concept that incorporated a complex six-blade configuration. Ultimately the designer decided to reduce the number of wing blades.

◀ Eaves' final color design sketches of the locked design. On direction from *ENTERPRISE*'s producers, the teeth were added once more, with a blood motif on the wings and nose section.

▼ This spread: three stages of John Eaves'
initial concept for the Denobulan medical
ship – black and white, first bronze coloring,
and an unused white variant, influenced by
Earth medical vehicles.

DESIGNING THE
DENOBULAN MEDICAL SHIP

For John Eaves, designing the Denobulan medical ship was a simple assignment that just needed a dash of color...

As a senior illustrator in the *STAR TREK: ENTERPRISE* art department, the task of designing the Denobulan medical ship featured in 'Cold Station 12' and 'The Augments' fell to John Eaves.

"They said it was part two of a three-part story arc with Dr. Soong," recalls Eaves. "We had only done one Denobulan ship before, kind of a cruiser. It was very fish like and bulbous, so I carried that through to the medical ship, but made an extrapolated version of that smaller ship. That first black-and-white sketch was actually the one they chose. I didn't have to do 50 or 60 sketches like usual. That never happened on the first drawing!

FILLING IN THE BLANKS

"They liked it right off the bat," continues Eaves. "This was the only view I did, this three-quarter view, although I did a little rear view for an FX shot." By 2004, leaps in CG visual FX had developed the concept art process. "What was nice about *ENTERPRISE* was that I'd give them this three-quarter view, and the CG modelers would take it and fill in the blanks. When I was in the model shop, we'd get really detailed plans, and you had to follow them to the letter. You couldn't add any creativity. When I got into this field, I left a lot of stuff open so the next guy that gets it can add their artistic side to it."

Eaves found that process allowed for greater freedom in coming up with new ship designs. "We got to break that rule

Denobulan Medical Vessel "Enterprise IV"
'C-12' JohEaves 8/04 Scheme "A"

"Enterprise IV" Denobulan Medical Vessel
JohEaves 8/04 "C-12"

that everything had to have a nose and tail. It could be upright, it could go round, be crazy, it could be crab-shaped. Everything was accessible in the design process."

While not seen in the final episodes, the concept designer gave thought to other ship operations beyond basic flight. "There's all kind of ports you could come in and out of when it's docked. You get those dorsal fins on the bottom. I never had to detail that but I imagine it would land on the upper end of those fins and a ramp would drop below."

TRADITIONAL METHODS

"These sketches are all just in pen and ink," Eaves explains his working process, "which I still do, except I color in Photoshop now. I still draw everything by hand and scan it."

With the initial design accepted, Eaves proceeded to experiment with hull coloring and markings. "We were going with bronzes and browns and golds in the first two phases. There was a first color pass and the second one with a little bit of break added."

MEDICAL COLOR

One experiment with color took its inspiration from the ship's medical duties. "It's a medical ship," adds Eaves, "so we also went white and blue. That's an Earth-bound color, the white for medical, so we strayed away from it with the alien version, but they wanted to see that version."

The final part of the process was to place the ship into a sketch with a concept for the Cold Station 12 asteroid. "A very smooth assignment," sums up Eaves. "It was an easy one as far as the ship design went, so that was nice, and then it was just a matter of color, which is always fun to do."

◀ Eaves' black-and-white concept drawing of the Denobulan ship *Barzai* approaching Cold Station 12, drawn in pen and ink.

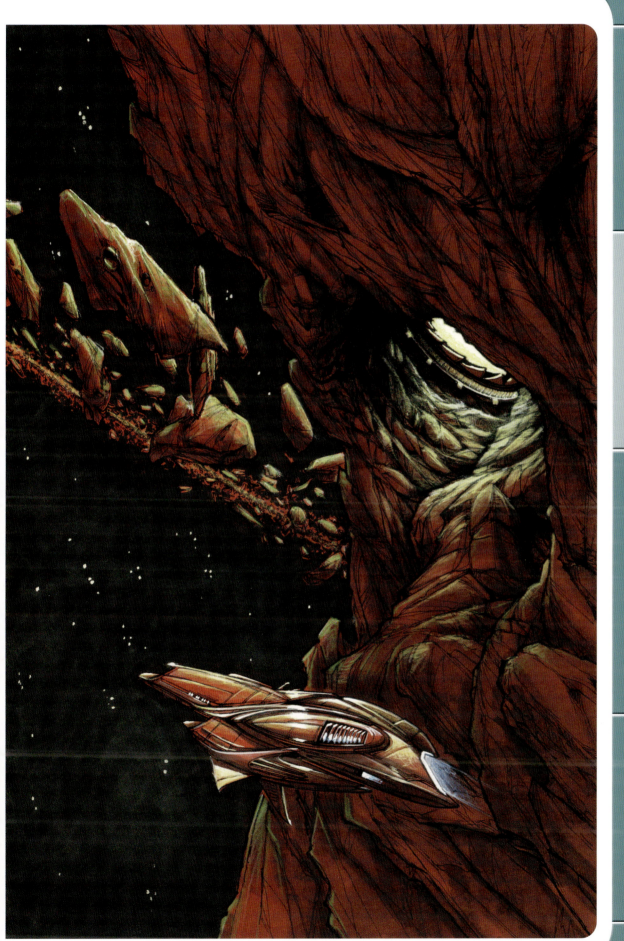

◄ Eaves added colour to the final concept sketch with marker pens. "These sketches are all just in pen and ink," says Eaves, "which I still do, except I color in Photoshop now. I still draw everything by hand and scan it."

▼ Eaves' first design was the biggest departure from the established Ferengi look - it was a small, vertical ship, and was his personal favorite of the three options he presented.

DESIGNING THE 22ND-CENTURY
FERENGI SHIP

The Ferengi was another familiar culture that appeared on ENTERPRISE years before the ships we knew would be designed.

In *ENTERPRISE*'s first season, Archer and his crew encountered the Ferengi for the first time. This was more than two centuries before the two cultures would establish lasting contact, so the and their ship would be forgotten.

When concept artist John Eaves was given the beat sheet, he knew that he had to design something in keeping with what was known about the Ferengi, but wouldn't be too obvious.

THREE SKETCHES
Eaves produced three sketches for the producers to consider: a vertical design, which was his favorite, one that was relatively close to the Ferengi shuttle that had appeared on *DEEP SPACE*

NINE, and finally a ship that condensed the elements of Andrew Probert's familiar Ferengi Marauder. This last sketch was chosen by producers, who accepted it without any modifications. Eaves remembers that he didn't need take a second pass before his drawing was passed on to the team at Eden FX, who built the CG model.

► The second option Eaves presented was closely related to the design of Quark's Ferengi shuttle, and shared its pincers at the front.

▼ The final option, and that chosen by the producers, took the elements of Andrew Probert's Ferengi Marauder and altered its proportions to create a new design.

▼ This was John Eaves' initial sketch for the Xindi-Primate starship. It included many blade-like edges to give it an aggressive look, and he also made use of open space in its configuration. Everyone loved this design and it was approved straight away.

STARSHIP

John Eaves explains how he came up with an aggressive look for the Xindi-Primate starship based on Arnold Schwarzenegger's sword.

Being a concept designer, on a show like *ENTERPRISE*, there is always another piece of alien hardware to invent. This means having to be constantly on the look out for inspiration. Influences can come from anywhere, and when it was time to design the Xindi-Primate starship, illustrator John Eaves had recently rewatched *Conan the Barbarian*.

"Conan's sword, which was designed by the legendary Ron Cobb, had always fascinated me," says Eaves. "I thought it would be cool to try and include some similar type of sword

▼ Eaves drew up a more detailed illustration of the design, and fleshed out some of his ideas. He also included a sketch of Degra's ship alongside the Xindi-Primate starship to show its comparative size.

Degra's ship for scale

Xindi Hominoid Ship + Details — Degra's ship for scale
Enterprise III. THE COUNCIL #74

blades into the Primate ship. That was where the initial inspiration came from, and I experimented with various blade shapes and put them down the sides and up at the front of the ship."

As the Xindi were the antagonists of the third season of *ENTERPRISE*, Eaves was told the Primate ship had to look threatening, and he felt the sword blade-look fulfilled that side of the brief. He also knew that the Primate starship had to be distinct from the vessels used by the other Xindi species, but at the same time they should all share similar motifs in their structure. As the Xindi

makeup showed that all their species had a common ancestor by featuring indented ridges on their faces, Eaves wanted to include elements in their starships that tied them together.

SHARP EDGED
"Most of the Xindi ships featured sharp-edged knife shapes or parts that resembled claws or talons," adds Eaves. "The Xindi-Insectoid ships had a three-pronged structure to them that definitely looked like claws, and most of the other Xindi species had vessels that included knife and blade-like

instruments to them."

The Xindi-Primate starship was distinct from the other Xindi vessels, mainly in the way it made use of open and negative space. "The design featured a central area, more like a conventional starship, where the operations took place, and the back half was where all the engines were located," says Eaves. "But the front featured a semi-sword open frame idea. We had tried to include open space earlier when they filmed with practical models, but it wound up being an enormous issue with the bluescreen when they filmed, and it

▼ Eaves began experimenting with color for the ship, subtly adding different shades to highlight different areas and bring out its details.

never worked. (Production designer) Herman Zimmerman always liked it when we included open and negative space in a starship design, but we were only able to do it when we switched to CG models. We were then able to design much more complicated configurations for the starships, as they were then able to film CG models without any problems."

FIRST TIME DESIGN
Once Eaves had come up with a design

he drew up a fairly rough illustration of it, and to his surprise it was approved right away, which hardly ever happened. He then began to flesh it out in more detailed drawings, and actually spent just as much time working on the color palette for it. "We had to figure out if we were going to do a solid color, or something else," says Eaves. "I did a whole exploration of what the colors would be like, and I experimented with a camouflage pattern.

"The U.S. Air Force had this blue digital

camouflage pattern that was new at the time, and a friend from Edwards Air Force Base had sent me a picture of it. I thought it looked cool and I experimented with something similar on the Primate starship. I used the pattern, but modified it by taking out the digital-look of it because it was boxy. Then, I tried a sort of zebra stripe, but they were all rejected. In the end, they went for a solid gray-green color that was more in keeping with the shade they had used on the other Xindi ships."

▼ After seeing an image of a U.S. Air Force fighter jet with blue camouflage, Eaves looked to add a similar color scheme to the Xindi-Primate starship.

▼ Eaves tried several different types of camouflage pattern for the Primate ship, but in the end the producers wanted a solid paint scheme that was more like the other Xindi ships.

STAR TREK ILLUSTRATED HANDBOOKS

STAR TREK ILLUSTRATED HANDBOOKS is a series of books that provide in-depth profiles of the *STAR TREK* universe, covering a wide range of topics from individual starships to races such as the Klingons. Each full-color, heavily illustrated reference work is packed with isometric illustrations, artwork, photographs and CG renders, and features detailed technical information from official sources.

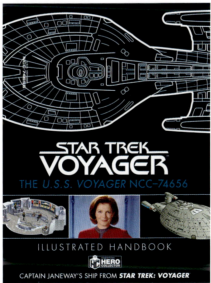

www.herocollector.com/books

STAR TREK SHIPYARDS

STAR TREK SHIPYARDS is a series of lavishly illustrated books that provides in-universe profiles of *STAR TREK* ships, building into the ultimate illustrated encyclopedia of *STAR TREK* vessels. Each ship is profiled with technical information, operational history and plan view CG renders – wherever possible using the original VFX models that were used on the TV shows and movies.

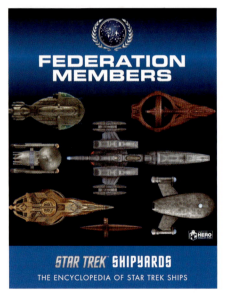

STAR TREK DESIGNING STARSHIPS

DESIGNING STARSHIPS is a series of lavishly illustrated art books that detail the design process behind the most memorable ships in *STAR TREK*'s history. Each book showcases original production artwork, and features in-depth interviews with the concept artists who created the ships, exploring exactly how each ship was created and offering a fascinating glimpse of what could have been.

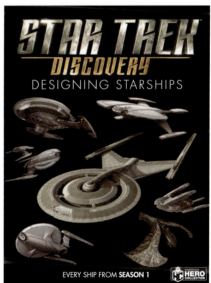

CREDITS

General Editor: Ben Robinson

Project Manager: Jo Bourne

Writers: Ben Robinson, Marcus Riley and Mark Wright

Sub Editor: Mark Wright

Designer: Stephen Scanlan

With thanks to the team at CBS: John Van Citters, Marian Cordry

and Risa Kessler

Published by **Hero Collector Books**, a division of Eaglemoss Ltd. 2021

Eaglemoss Ltd., Premier Place, 2 & A Half Devonshire Square, EC2M 4UJ, London, UK

Eaglemoss France, 144 Avenue Charles de Gaulle, 92200 Neuilly-Sur-Seine, France

The contents of this book were originally published in *STAR TREK – The Official Starships Collection* by
Eaglemoss Ltd. 2013-2021

ISBN ISBN 978-1-85875-989-0

Printed in China

PR7EN001BK

www.herocollector.com